AUDLEY
THROUGH TIME
Tony Lancaster

AMBERLEY PUBLISHING

The Organisation of the Book

The book is intended to take the reader on a journey through Audley Parish. It starts from the west along the Nantwich Road and then explores Audley itself before travelling to the 'ends' and townships that make up the rest of the parish. There will be stops on the way to illustrate the varied economic, social, educational, religious and cultural life of the parish, both past and present. It is not always easy to present a balanced picture, especially of the industrial past of the parish. Much of this has disappeared. There are no pits left and no railway. But there are contrasts with that past and the appearance of the village still reflects that past in, for example, its terraced houses. Village life inevitably changes and the pictures in this book are an attempt to record those changes rather than pass judgement on them.

First published 2009

Amberley Publishing Plc
Cirencester Road, Chalford,
Stroud, Gloucestershire, GL6 8PE

www.amberley-books.com

Copyright © Tony Lancaster, 2009

The right of Tony Lancaster to be identified as the
Author of this work has been asserted in accordance
with the Copyrights, Designs and Patents Act 1988.

ISBN 978 1 84868 645 8

British Library Cataloguing in Publication Data.
A catalogue record for this book is available from
the British Library.

Typeset in 9.5pt on 12pt Celeste.
Typesetting by Amberley Publishing.
Printed in the UK.

Introduction

The parish of Audley lies in the north-west corner of Staffordshire, bordering Cheshire. Much of the parish is situated on high ground, with striking views across the Cheshire plain to the north and west. A contrasting landscape lies to the south and east, that of the North Staffordshire coalfield and the urban areas of Newcastle under Lyme and the Potteries.

In 1951, approaching the parish from the east, a writer used the word 'drab' three times on one page to describe 'the mining district' he passed through (by bicycle!) However, at the sight of Audley, he cheered up: 'Peaceful, rural Audley … is a pleasant spot, a far cry from the drabness of some of the villages to the east' (P. H. Mountford). Today, there are no coal mines in the district, but Mountford's enthusiasm for Audley and the 'ends' and other components that make up the parish would probably be just as great. This is how he described the parish in 1951:

> … a country road runs to Miles Green, a scattered community at the foot of wooded hills, and Halmerend, a semi-rural village on the lower slopes of a steep hill on the top of which is its exposed and windswept neighbour, Alsagers Bank. Among the hills lies Wood Lane, an isolated community which is still without a bus service, owing to the narrowness and difficulty of the roads.

Much of that description remains accurate, though Wood Lane has its bus service. The missing element of the description is Bignall End, referred to only as 'a colliery district'. Now, the collieries have gone and it is a mainly residential area.

The first document to mention Audley (Aldidelege in its Anglo-Saxon version) is the Domesday Survey of 1086. Two visible reminders of medieval Audley remain: the mound (or 'motte') of the castle site and the church, the oldest parts of which date from the fourteenth century. Castle and church were built on a continuous ridge, which later was sliced through by the road that still runs between them. The lords of the manor, the Audleys, became an influential family in the medieval period, serving the monarchy in a variety of military and civil offices. Branches of the family lived at Audley End in Essex and Audley's Castle in Northern Ireland. By the end of the sixteenth century, however, the family had fallen on hard times and sold the manorial lands of Audley. A series of landowners followed but they were often absentee landlords and Audley

was not a 'lord of the manor' village. The prominent landowners of the nineteenth and twentieth centuries, like the Bougheys and Heathcotes, made their money from the main local industry, coal mining.

Until the eighteenth century, the chief occupation in the parish was agriculture with its associated trades. The eighteenth century saw a major change. Small pockets of industry already existed to exploit the iron and coal resources long worked in the North Staffordshire area. By 1800, there were six collieries at work in Audley, though the main expansion of the industry came after the middle of the nineteenth century. Coal was needed by the salt industry of Cheshire and, more importantly, by the Potteries. The coal had to be moved quickly and this led to road improvements. In 1766, Nantwich Road, which ran through Audley and on to Newcastle under Lyme, was turnpiked by an Act of Parliament. Josiah Wedgwood was one of the trustees of the Turnpike Trust that was to administer the road. It was about 100 years later that Audley got its railway line, the Audley Branch of the North Staffordshire Railway, opened for goods traffic in 1870. Coal mining was now a large-scale industry in the Audley Parish, with better transport to shift the coal. Population rose rapidly and by 1901 had reached 13,918, a six-fold increase since 1801. In the good times, the mines brought wealth to their owners and jobs for a large number of men. Mining, however, was a hard and hazardous occupation, and a number of dreadful pit disasters are still well remembered in the village.

In the 1920s and '30s, the coal mining industry declined rapidly, resulting in widespread pit closures. Population declined and Audley lost its status as an Urban District Council in 1932. It became part of the borough of Newcastle under Lyme. Within its existing boundaries, the population of Audley was 8,192 at the 2001 census, increasing to 8,452 by 2007.

In more recent times, the parish has seen great changes. It has entered the age of the motor car. Like so many other villages, it has become a desirable place for commuters to live. According to the 2001 census, 78 per cent of the working population, about 3,000 people, travelled to work by car either as driver or passenger. Commuting and wide car ownership make the population more mobile, but cars also bring noise, pollution and clogged-up roads. Shops and businesses in the village struggle to survive the competition of out of town stores and supermarkets. There have also been considerable changes in the physical appearance of the village. One example is the demolition of so many of the large and impressive chapels in the area. Another is the large-scale house building that has occurred since 1945.There is, however, also considerable continuity in the life of the village. Agriculture remains an enduring presence. There is considerable continuity in village families, suggested by familiar names, which recur in historical records. Clubs and other leisure activities have survived.

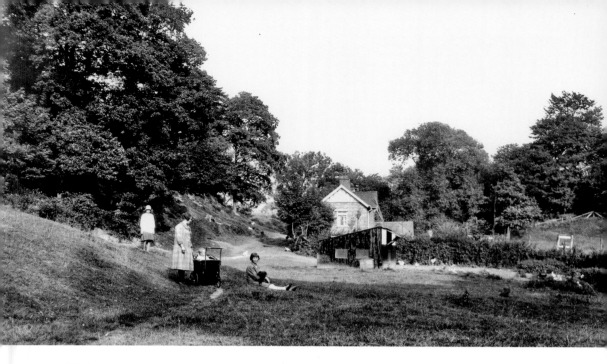

Mill Dale

This peaceful scene can still be found a short walk from Nantwich Road, historically the approach to Audley from the west. The mill, called Knight's Mill, had ceased to function by the early nineteenth century. The picnickers of the 1920s are enjoying the rural tranquillity that still draws local walkers to the dale today. These pictures are a reminder that, while much in the parish has changed, there are still areas unaffected by the motorised bustle of more recent times.

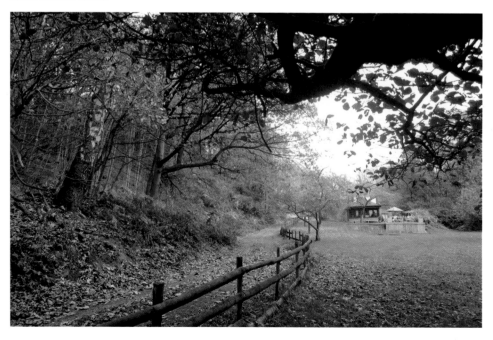

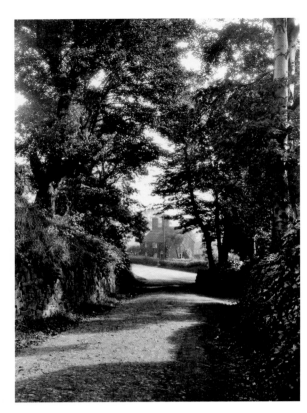

Junction of Nantwich and Barthomley Roads

A little further along this same approach to the village, Nantwich Road meets a road from the pretty Cheshire village of Barthomley, some two miles away. Nantwich Road was turnpiked in 1766 with the support of manufacturers like Josiah Wedgwood who were anxious to improve communications in the area. The rural aspect of the scenery persists, at a point where the road was re-aligned.

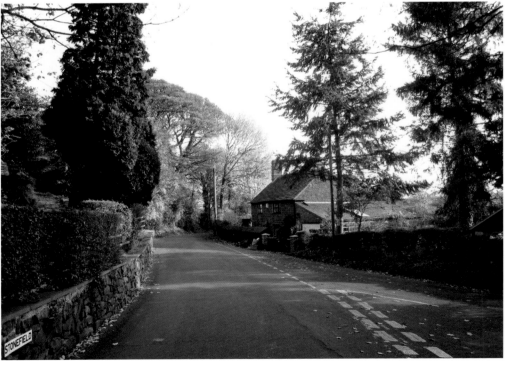

The Approach to the Village

Nantwich Road was still a narrow, tree-lined lane in the early twentieth century. In this winter scene, Audley Church is visible, with Audley Old Hall to the left. Set back on the right is Wall Farm. The road is now wider and very much busier. The left-hand side of the road has retained more of its rural aspect and the modern picture looks down on the ribbon development that now reaches the junction shown in the previous pictures. In the background, the considerable growth of housing since 1945 is clearly evident.

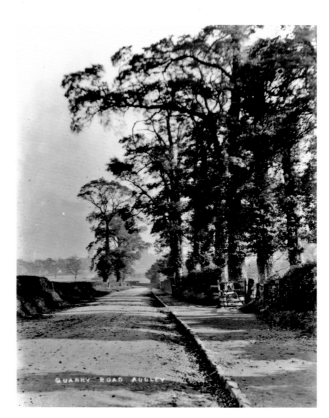

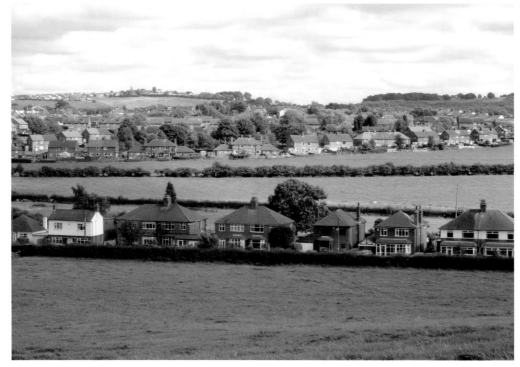

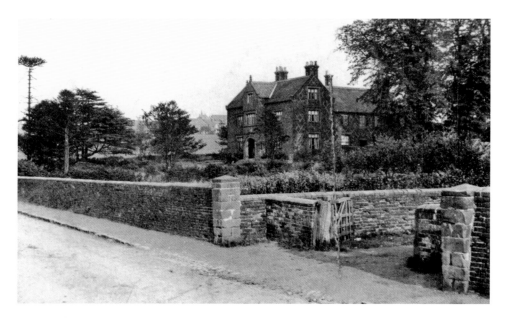

Wall Farm

Wall Farm is shown in a picture from the 1930s. The farm has origins in the eighteenth century and the house in the nineteenth. The inset shows a group of young women, who were learning the art of butter making at Wall Farm in the 1920s — a reminder that butter and cheese were still often made locally. In the recent photograph, Wall Farm, now a private residence, nestles in the trees on the left. The farm buildings and the farm land are still in use.

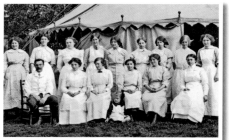

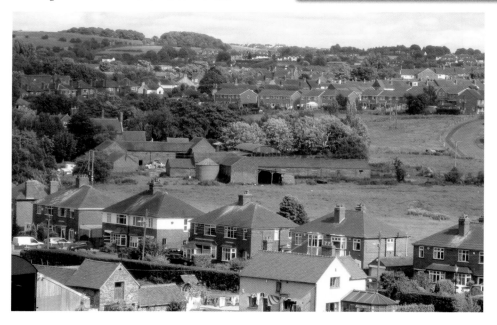

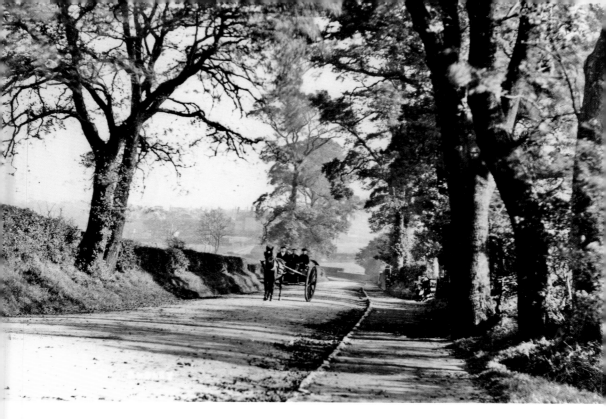

Nearing Audley Village

The old picture captures beautifully the atmosphere of a quieter, slower-paced rural life. On the right of the picture is the entrance to Wall Farm, now flanked by the garage. The road is built up on both sides, the trees have gone and the solitary horse and trap has been replaced by the ever-present motor car. The church tower is just visible above the trees.

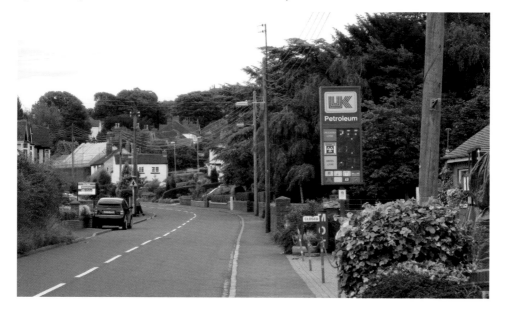

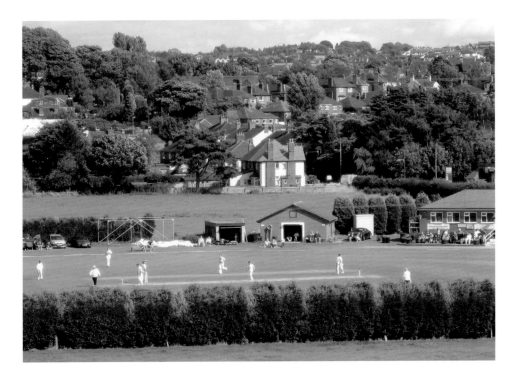

Audley Cricket Ground

The rural aspect of the approach to the village has been maintained on the left-hand side of Nantwich Road. A footpath still gives access onto Kent Hills, a favourite walking area and the site of Audley Cricket Club since 1885. The ground has seen much improvement over the years, including the building of a new pavilion in 1963.The days of the canvas sight screens and uneven playing surfaces are long gone. Cricket has enjoyed great popularity in the area since the middle of the nineteenth century, with still-thriving clubs at Audley, Bignall End and Wood Lane. In the old photograph, Audley village, with its parish church, stands on a ridge. The open road (centre left) is Chester Road, still a country lane.

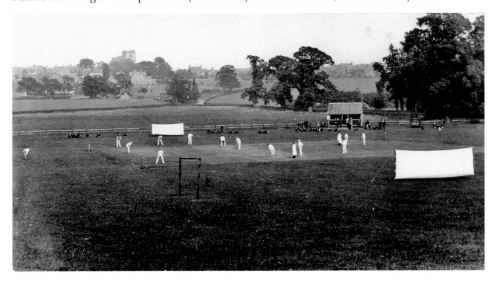

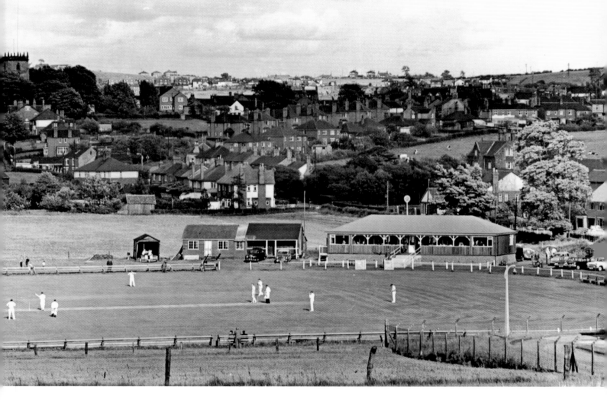

Audley from the Kent Hills

This splendid, panoramic photograph looks up to the heart of the village, and, at first glance, seems similar to the view today. But two important features have disappeared: the large Methodist chapel (right, top) and the Croft (the open area just below the church). Chester Road is now built up. The modern picture shows a large-scale area of housing at the right — the edge of the large council estate built after 1945.

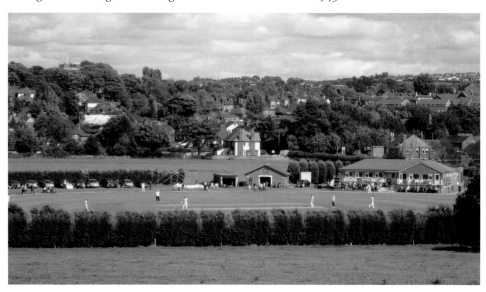

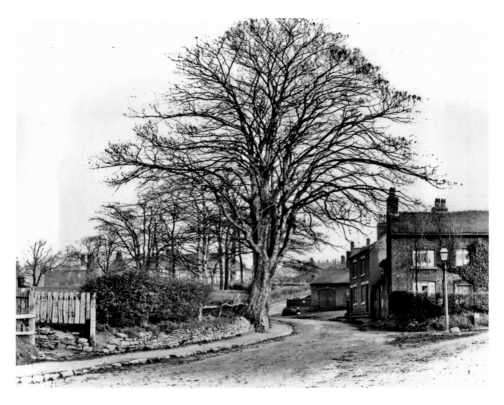

The Junction of Nantwich Road and Chester Road

There have been considerable changes at this junction of three roads which all lead into the heart of Audley village: Nantwich Road, Chester Road first right, Wilbraham's Walk second right. The cottages in the foreground remain but the smithy (the low building in the centre) and Audley Old Hall (to the left through the trees) have been pulled down. The smithy became a garage, as cars replaced horses. It is currently being replaced by housing.

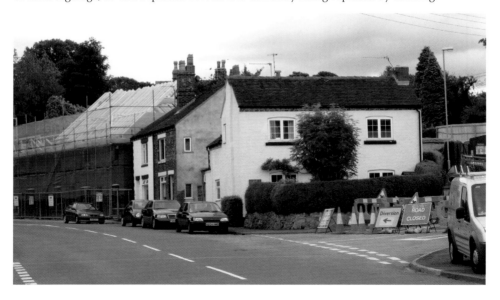

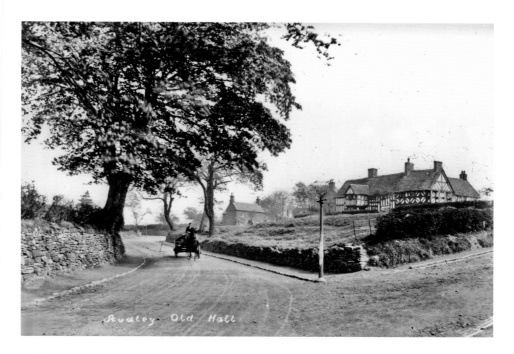

Audley Old Hall

This impressive timber-framed building, once the home of a well-known local family, the Vernons, fell into disrepair in the 1920s. It had become uneconomic to maintain the property and it then came under multiple occupation. In 1932, it was pulled down and has been replaced by modern housing. Wilbraham's Walk is to the right.

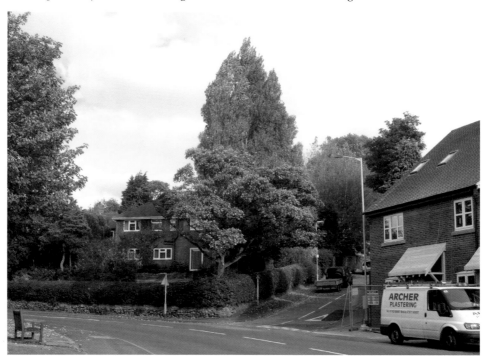

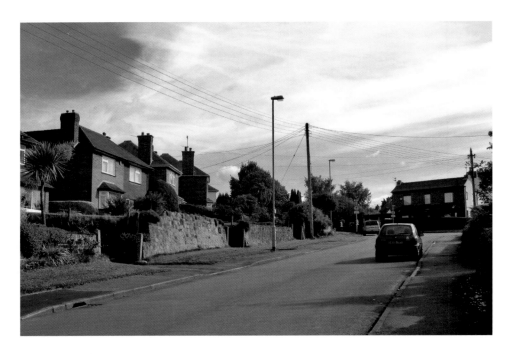

Chester Road

One way into the centre of Audley village is via Chester Road. Earlier in the twentieth century, the lower half of the road was narrow and undeveloped. It was bordered on the left by the church glebe land. The house facing down the road marks the junction with Dean Hollow, a small lane through to Church Street. Chester Road is now built up on both sides. The right-hand side was developed in the 1920s and 1930s. The detached houses on the left were built in the 1950s on land purchased from the church and the road has been widened.

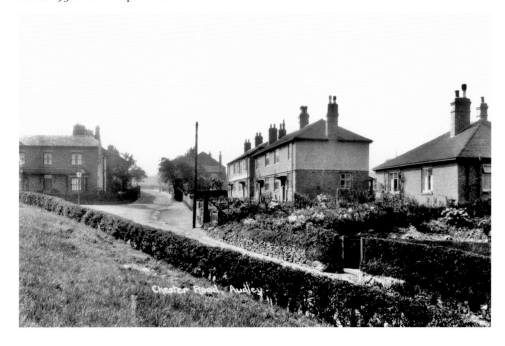

The Croft

The children are playing cricket on the church glebe land behind the old vicarage. This open space was eventually sold by the church, and the recent photograph was taken from the garden of the now-private property. The church and the back of the old vicarage can be seen through the trees.

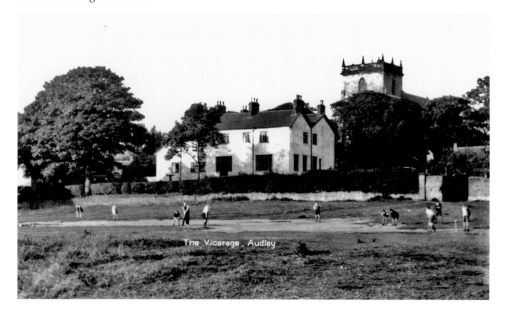

The Vicarage, Audley

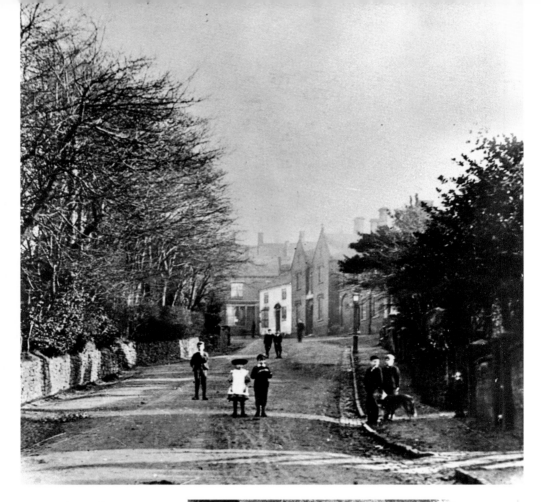

Nantwich Road up to Church Street

The view in the early picture remains little changed as Nantwich Road sweeps uphill towards Church Street. The housing retains its attractive nineteenth- or early-twentieth-century appearance. A number of the houses are marked on the Ordnance Survey map of 1833. The public house (top right) remains, with some changes to buildings after that. The bottom of the road is now an important junction, with a road leading left to link with the M6.

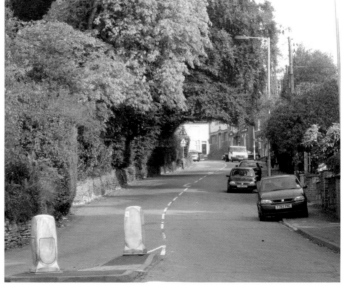

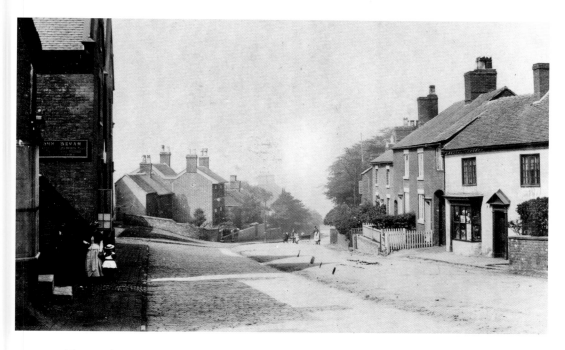

Looking Back

Again, the view has not changed dramatically. Just appearing on the left in the early picture are the Market Hall and Boughey Arms. The shop opposite is now a private house. Other businesses, including a garage just below the white house, have also disappeared.

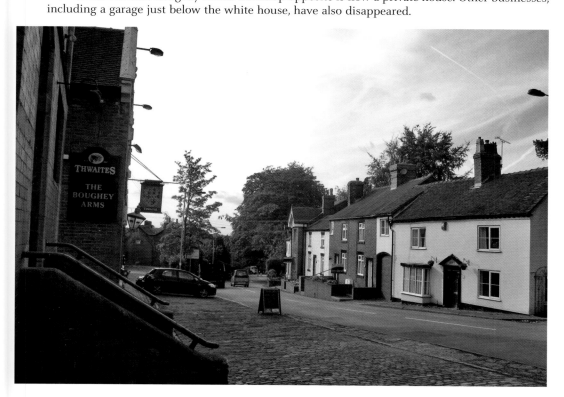

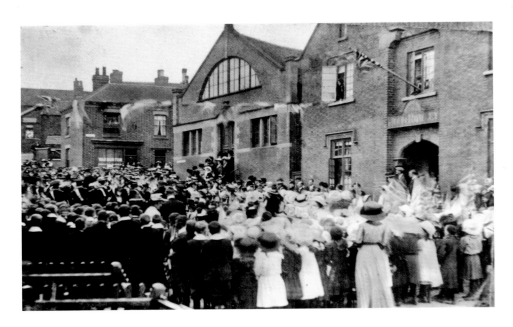

Celebrations Outside the Market Hall

This splendid turnout may have been for the visit of George V in 1913. It took place in front of the Market Hall, built in the early twentieth century. After a short life as a market, the building has had a chequered career. At one time, it was a knitwear factory, then it was the village hall and now it belongs to the Boughey Arms next door. This public house is named after the last lords of the manor in Audley. On the opposite corner of Church Street stands a shop, now a private house. The house at the top of the drive is a former public house.

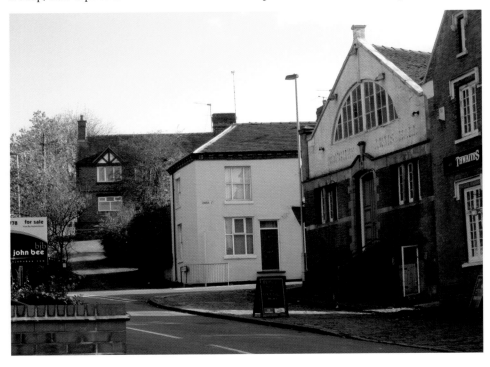

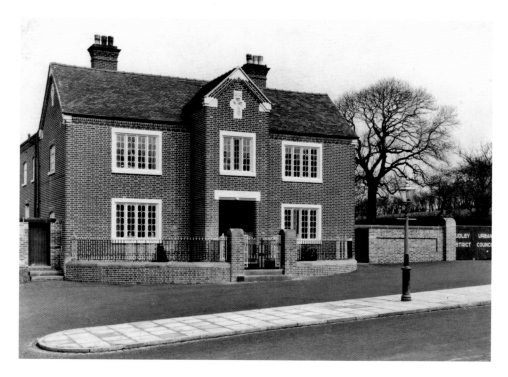

The Council Offices

Formerly Castle Hill Farm, this impressive Victorian building (1870) was converted into the offices of the Audley Urban District Council in 1930. However, in 1932, Audley lost its status as an Urban District Council and became part of Newcastle under Lyme Borough. The building was later used for adult education classes, as well as meetings. More recently, after falling into disrepair and being threatened with demolition, the building has been taken over by an outdoor activities firm. To the right is Castle Hill, the site of Audley's ancient castle.

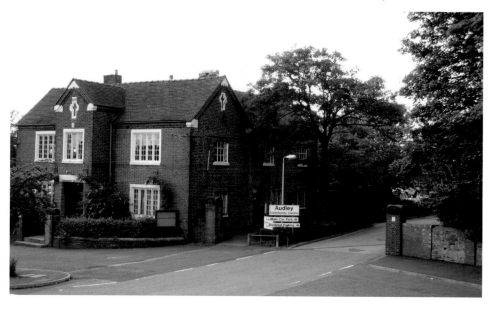

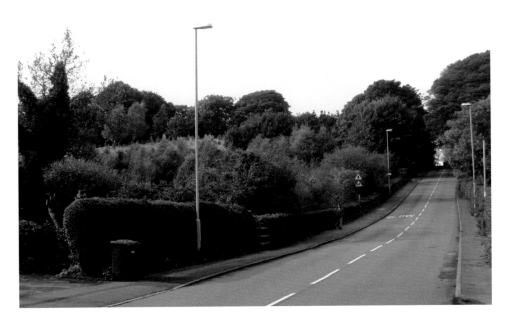

Castle Hill

The early view was taken from the other side of Castle Hill. It shows very clearly the ridge chosen in the medieval period as the site of both church and castle. The road between the two came later and followed a different course. The one depicted now is New Road leading to Bignall End. Only the motte (mound) of the castle survives, the top of which is shown in the inset. Here, in the twelfth century, stood a wooden keep inside a stockade. The site was excavated before the First World War and has been made a scheduled monument by English Heritage. Most aptly, the motte became the historical focus of the Audley Millennium Green in the year 2000. As the modern picture shows, much of this view has now disappeared behind the trees.

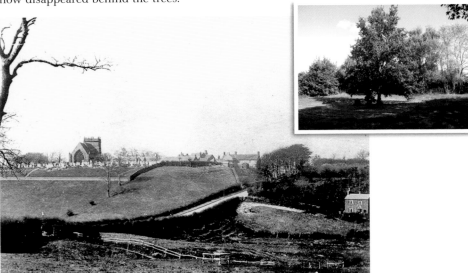

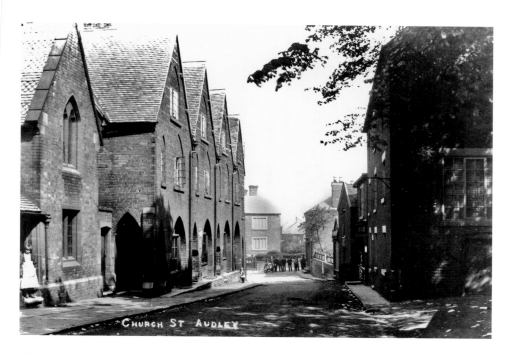

Church Street, Audley

This is the entrance into Church Street, the main thoroughfare of Audley. The group of people, with the Council Offices behind them, stand across the entrance to Church Street — a manoeuvre that would nowadays be life threatening! The buildings to the right, which included Audley's first post office, have all disappeared. To the left are the buildings designed by the Victorian architect William White; they are a major architectural feature of the village.

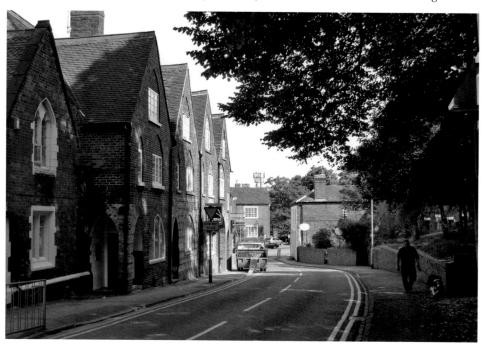

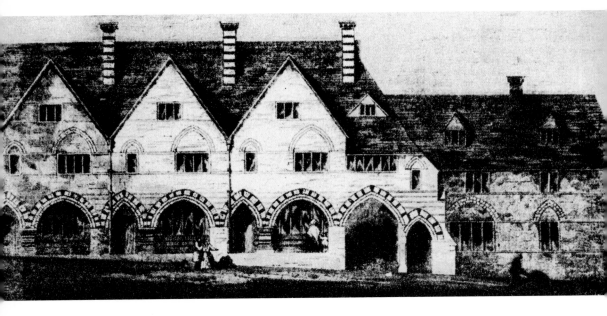

The William White Buildings

The drawing of White's design for these buildings was featured in architectural magazine the *Builder* in 1855. They have been much admired by the architectural historian Nicholas Pevsner. He calls them 'remarkable... something quite extraordinary ... a group of three shops, an archway and a house, brick and all Gothic but Gothic reduced to essentials'. Features mentioned in the *Builder* include the arcade to cover pedestrians, which the author compares with the Rows at Chester. There is an arched entrance between the third and fourth houses as an entrance to a stable yard. The buildings have survived many uses, and sometimes abuses, over the years. A variety of shops and businesses have used them, but only a ladies' hairdressers remains and the rest are private houses.

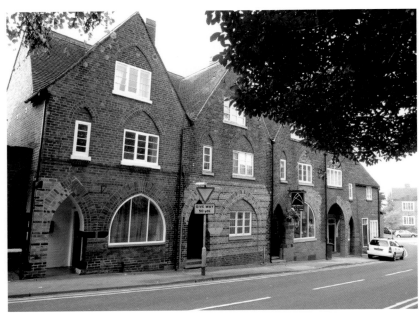

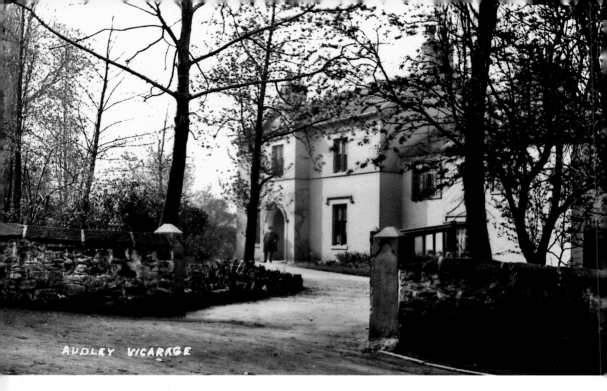

The Vicarage

The vicarage was built in 1833 by the then vicar, the Reverend Thomas Garrratt, at his own expense. It was much altered in 1936 and again more recently when it became a residential care home called Wilbraham House. The early picture shows the vicarage garden before some was taken for the cenotaph. The modern vicarage is just around the corner at the top of Wilbraham's Walk.

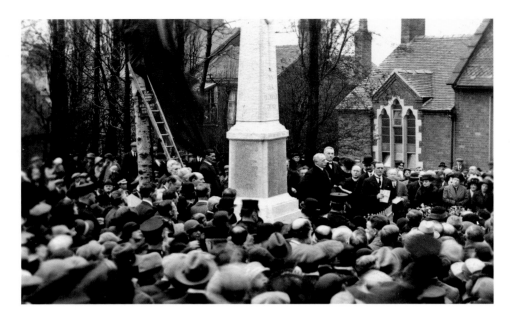

The Cenotaph

The top picture shows the unveiling of the cenotaph by Sir Francis Joseph in 1923. It commemorates the loss of 124 lives in the First World War. The memorial was positioned in a corner of the vicarage garden. The building on the right was a national boys' school until 1901, when it became an infant school. In 1938, the building became the parish hall and office, which it remains — with some rebuilding — today.

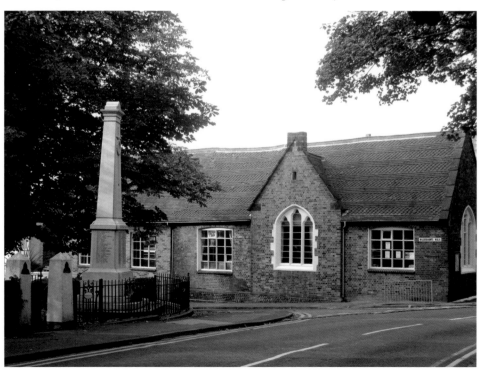

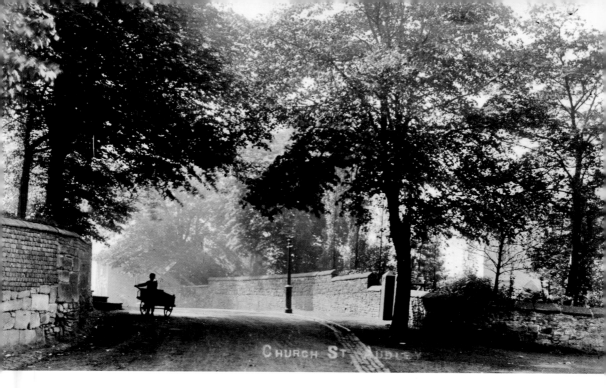

The Church Approach

Another artistic photograph by Thomas Warham depicts a still attractive part of Church Street. On the left, the steps lead to the churchyard, while on the right is the former vicarage, then mostly hidden by trees. Now many of the trees have gone, as has the brick watercourse. The war memorial has now changed the appearance of the corner, which leads into Wilbraham's Walk.

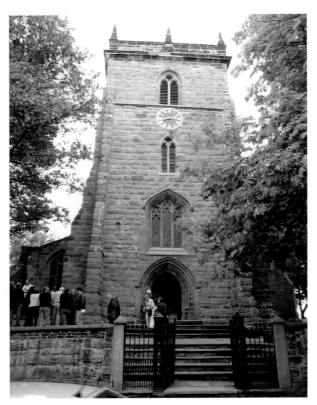

St James' Church

Situated in an elevated position on the same ridge as the castle, the impressive parish church of St James, built in red sandstone, dates from the fourteenth century. The large tower is from that period as are several features of an attractive interior. The tower has just emerged again from scaffolding used in an extensive renovation. This picture was taken at the open day in September 2009, to mark the completion of that work.

Views of the church are now restricted, particularly in the summer, by the growth of the magnificent trees shown in the modern picture.

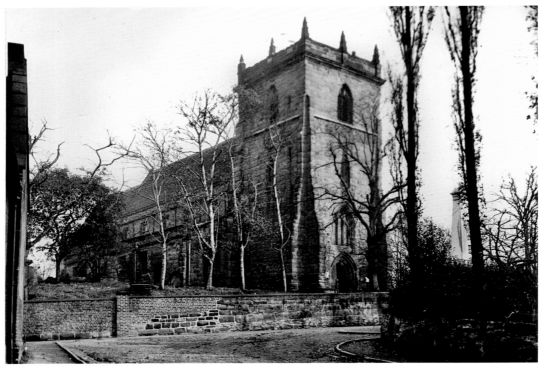

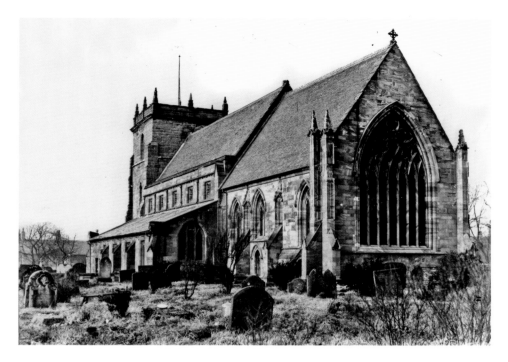

St James' Church

In the 1840s and early 1850s, the church underwent an extensive restoration by the church architect, Sir George Gilbert Scott. The church was feeling the competition of Methodism, particularly strong in North Staffordshire. The vicar, Charles Philip Wilbraham, was the driving force behind the restoration. The east end of the church and the clerestory windows, shown in the modern picture, were much altered by Scott. The attractive interior of the church contains a particularly good brass of Sir Thomas de Audley.

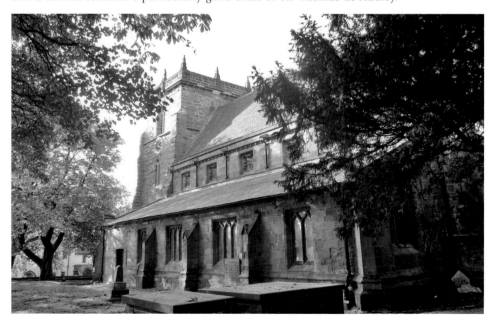

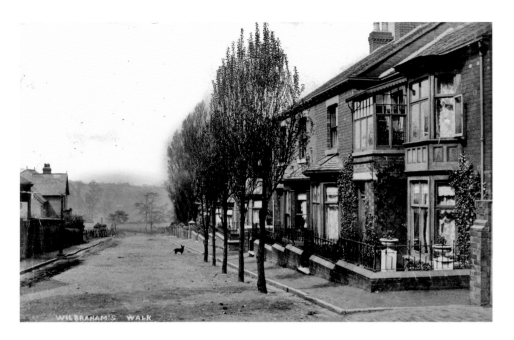

Wilbraham's Walk

This road leads down to the former Old Hall and smithy. It was named after Charles Philip Wilbraham, vicar of Audley from 1844-1874, 'a man of private means, an inveterate world traveller and known to a number of famous people including William Ewar Gladstone.' (R. Speake). Wilbraham presided over the church restoration by Gilbert Scott, during which Gladstone visited the church. The road remained unadopted and unsurfaced. The road is shown with still-existing housing to the right, but with left-hand side largely undeveloped. Now the road is fully built up on both sides.

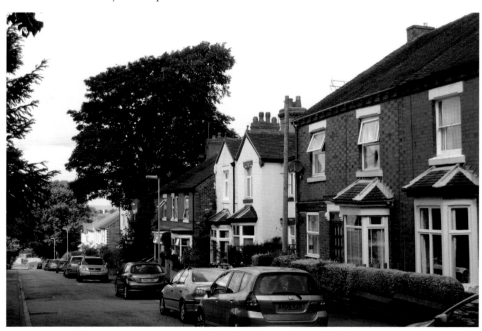

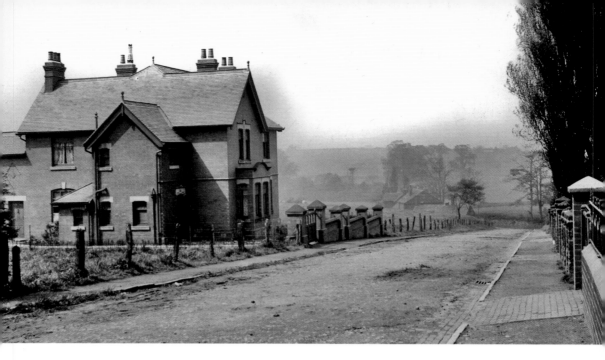

Wilbraham's Walk: the Manse

The house on the undeveloped left-hand side of Wilbraham's Walk was the manse, the residence of the Methodist minister from 1904. 'The new manse was a large, purpose-built detached residence which they (the Methodists) now owned in the most fashionable part of the village.' (David Dyble).

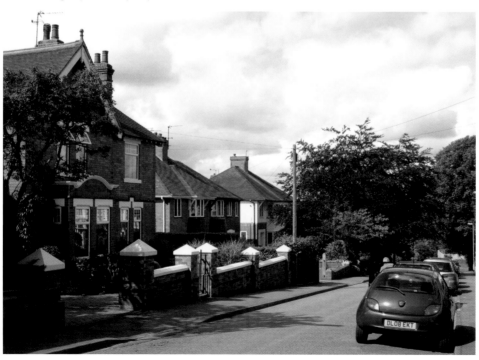

A Changing Scene: Farm to Medical Centre

The first buildings after the church, the nineteenth-century farm and the neighbouring house shown in the old picture, have both been demolished. They were replaced by a Health Centre (1976) and a Pensioners Hall (1979). The Health Centre shown in the modern picture was itself rebuilt as a two-storey building in 2007.

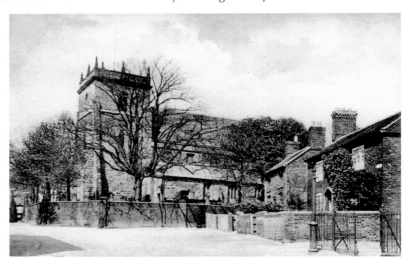

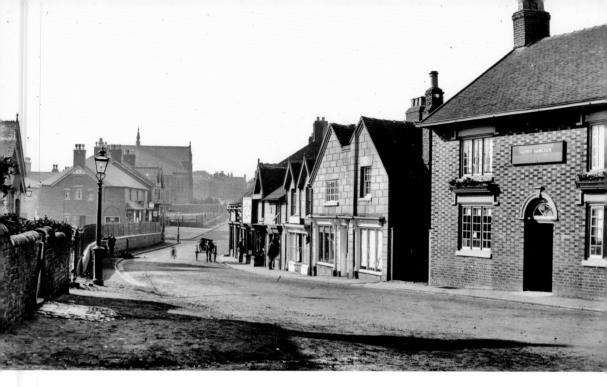

The Butchers Arms

The 1915 picture is a view of Church Street that shows, on the right, the Butchers Arms and a row of buildings, parts of which date from the seventeenth century. Prominent on the left is the Primitive Methodist chapel (1896). The modern picture reveals obvious changes in the appearance of the public house. It has also moved! In 1939, it was rebuilt and moved back from the roadside. The other buildings in these pictures will be examined as the journey is made along Church Street.

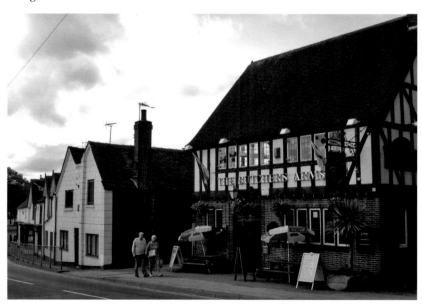

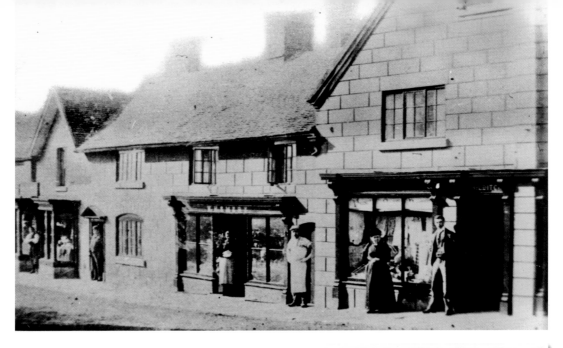

Nos 26-38 Church Street

This fine group of buildings may well contain the group described as 'the four houses called Tuttel Street' in a seventeenth-century account of Audley (Richard Parrott, *An Account of the Parish of Audley*, 1733). The large building on the right is a later addition, as are some of the gables further along. As the old picture shows, most of the buildings were used as shops — something that no longer applies. The inset shows Mr Steele at his door, with some interesting price labels in the window! When Parrott wrote, there would have been fields beyond this group of buildings.

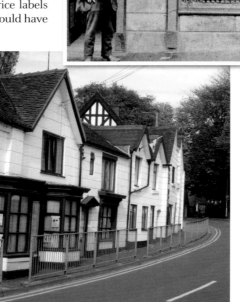

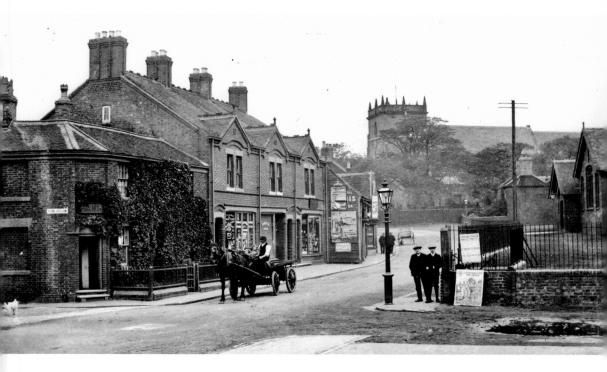

Early Twentieth-Century Church Street

The group of three shops and the ivy-clad National Provincial Bank have reached Dean Hollow, the narrow lane connecting Church Street with Chester Road. The church is clearly visible and on the right is Audley School. The two men by the gas lamp are standing at the entrance to Hall Street. To the right, the poster advertises *The Cheyenne's Love for a Sioux,* to be performed at the Market Hall. The modern picture shows that corner now as the entrance to Hall Street, with the library on the corner. The school has gone. The church is no longer visible through the trees. On the left, there is a change: the bank was rebuilt and expanded, though this is no longer a bank.

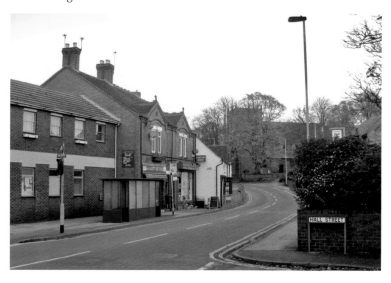

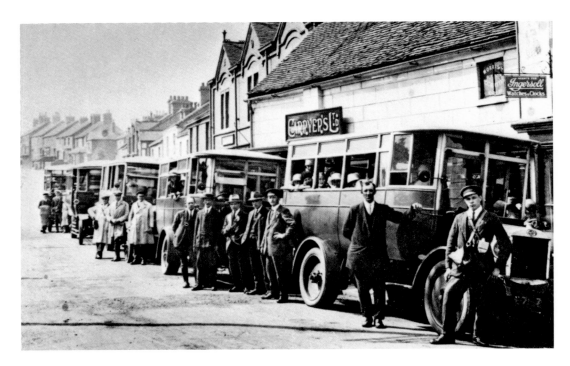

Bus Transport

A number of bus companies sprang up in the parish in the 1920s. Here, Johnsons' buses are obviously preparing for an outing. The passengers seem to enjoy posing for the photographer. Bus services still run from the same area of the village, although the heyday of public transport seems, at least for the time being, to have passed.

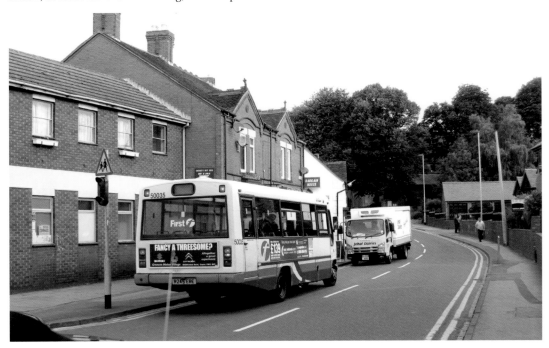

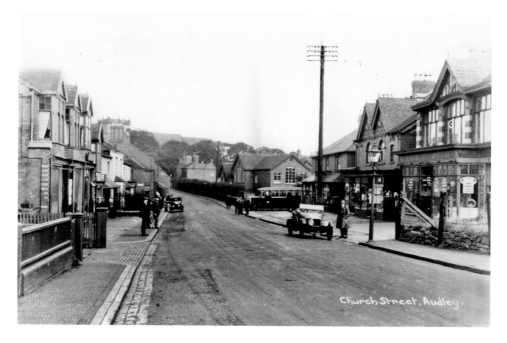

Church Street, Audley.

1920s Church Street

Cars — a few! — have now appeared on the street as well as a bus, waiting in Hall Street. On the right is a row of shops; the large Butt Lane Co-operative Society building (1914) stands out. The school is clearly seen beyond the bus, followed by the old buildings beside the church. The recent picture shows the modern Co-op building, next to the old Co-op building. This is now a balti restaurant. The motor age is in full swing.

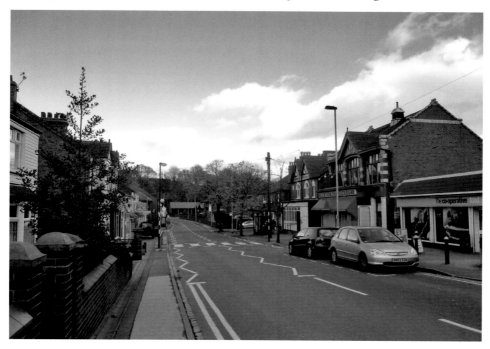

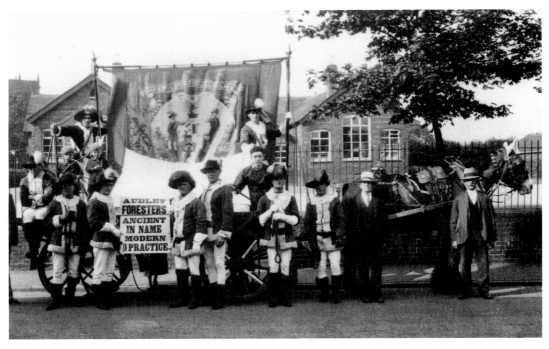

The Foresters' Procession

The number of photographs recording events like the one shown here suggests that the early twentieth century was an era of colourful processions in the village. Here, the Ancient Order of Foresters gather in front of the old school in the 1930s. Other societies — the Oddfellows and the Rechabites — also had strong followings in the parish. The Friendly Societies were a very important source of social security before the advent of the welfare state. They would be particularly important in a large mining community. Two foresters' sashes are also shown.

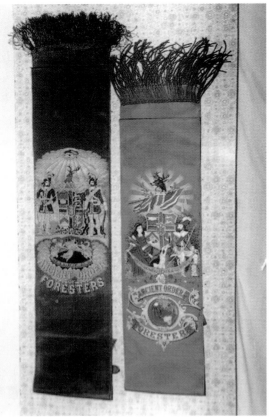

The Library

The Library Committee was set up after the First World War by ex-servicemen. They formed an association, one of whose functions was to man a free lending library in the village. The present public library (1966) was built on the corner of Hall Street.

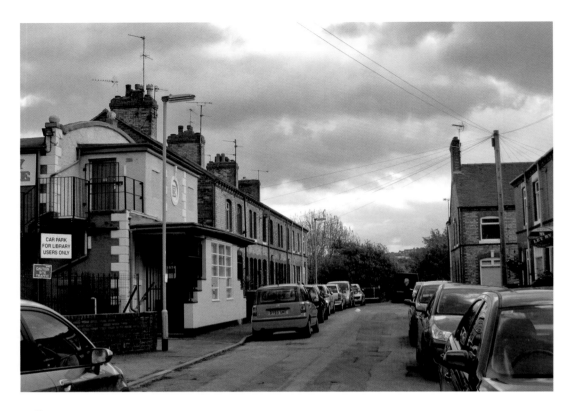

Hall Street

Built on the area formerly known as Leddy's Field, the neat terraces of Hall Street remain unchanged from *c.* 1910. On the left now is the library and, next to it, is Audley theatre — a cinema in the earlier picture. The open vista at the end of the street has gone with the development of a wildlife area, which uses the old name of the area, Leddy's Field.

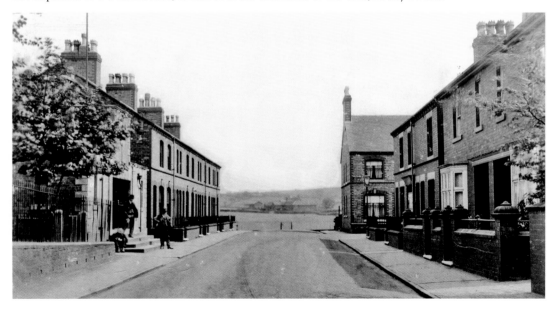

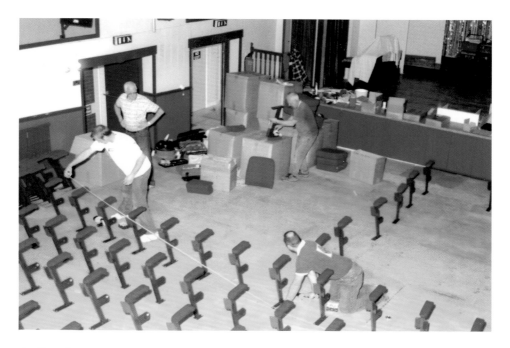

Audley Theatre

The popularity of cinema in the 1920s and '30s is captured by the picture of a Saturday children's matinée audience. The Audley cinema was built in 1910 and named the Coronation cinema to mark the coronation of George V in that year. As cinema audiences dwindled in the 1960s, the cinema closed. After a brief spell as a bingo hall, it was given new life in 1967 when it became Audley Theatre. The theatre has proved a great success ever since: the Audley Players put on plays, shows and an ever-popular traditional pantomime. A complete refurbishment of the seating, underway in the recent picture, has now been finished.

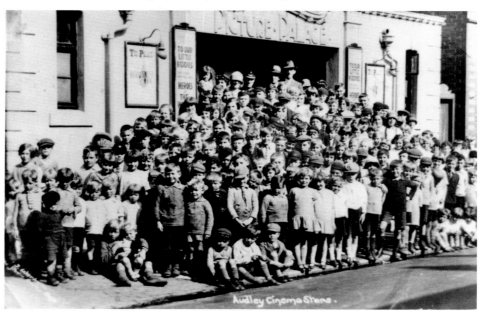

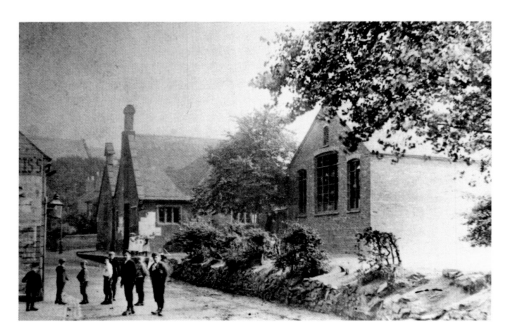

Audley School

Audley School, founded in 1839, was originally a girls' national school. In 1901, it became a mixed Church of England school and, in 1909, a council school. Finally, it became an infant school. With all these changes, the appearance of the school changed over the years. It was closed and then demolished in 1990, and the site was redeveloped with private dwellings, known as St James' Court.

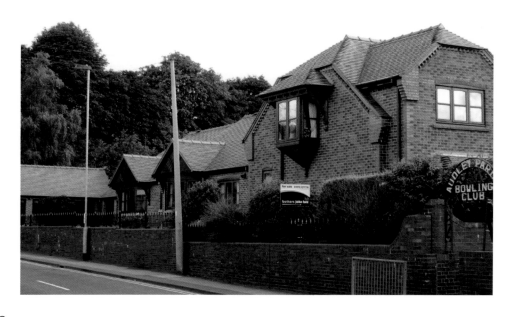

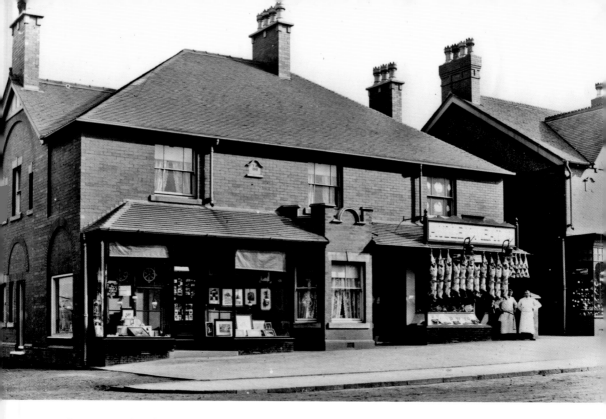

Thomas Warham's Studio

This plot on the corner of Hall Street was developed in 1910. Thomas Warham, the photographer responsible for many of the pictures in this book, had the corner shop and house built, with his studio at the rear. The shop sold pictures, stationery, fancy goods and toys. The adjoining shop, then a butcher's, became a greengrocers and remained so until recently. Now, both buildings are private residences; it is a clear illustration of a general decline in the number of village shops.

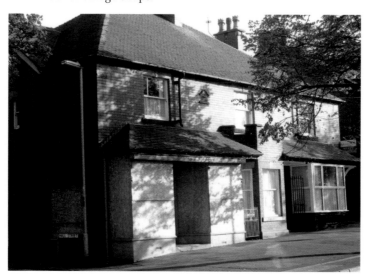

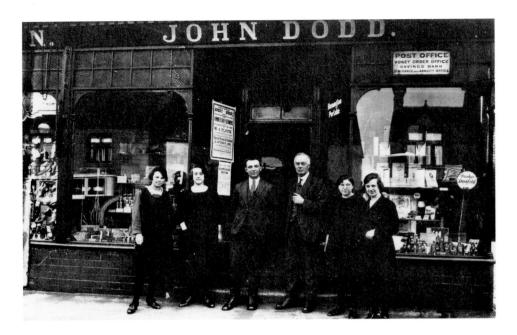

Audley Post Office, 1927

The post office was also the site of the Audley telephone exchange, with the number Audley 10, and it had twelve subscribers! John Dodd, pictured here, was the postmaster and a printer. Four sites along Church Street, including the present one, have been used as post offices. This building later became the Midland Bank — one of three banks, all of which have disappeared. It now houses a dental practice.

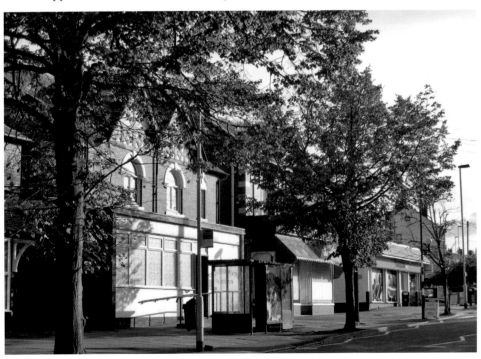

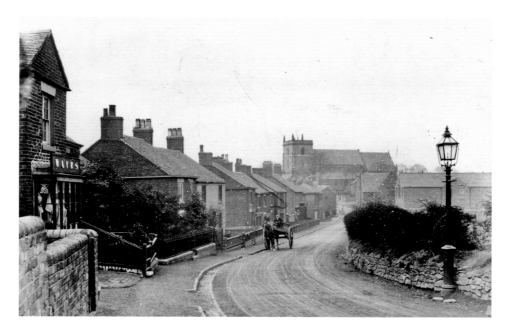

A View Before 1896

This photograph looks back towards the church. The clue to the date is the missing pinnacle on the church tower, replaced after 1896. Another indicator for this date is the absence of a chapel on the right-hand side of this view. There has been considerable change in the usage and, in several cases, the appearance of the properties on the left. The shop immediately left was a drapers, now a newsagents. Further down, there are more shop frontages.

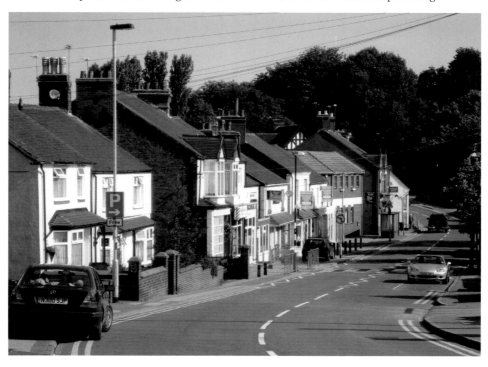

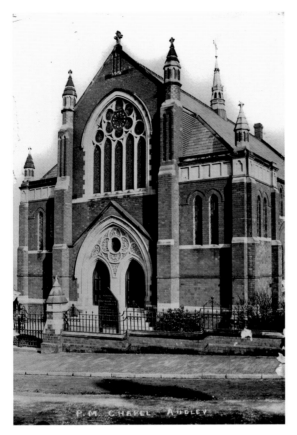

The Primitive Methodist Chapel, 1896

While the parish church dominated the northern end of Church Street, this chapel towered over the centre. It was built by the Primitive Methodists in 1896 to seat 600 worshippers at a cost of £3,000. It was a symbol of the strength of Primitive Methodism. There was rivalry between Wesleyan and Primitive Methodism in the area. It is only a few miles from the birthplace of Primitive Methodism, Mow Cop (a landmark clearly visible from several viewpoints in the parish). However, these large chapels became very expensive to maintain, and in 1973, the chapel was demolished. It was replaced by a car park and supermarket. It is the towering sign of the shop that now dominates views along Church Street rather than the chapel.

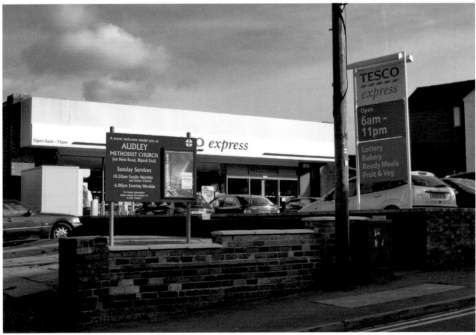

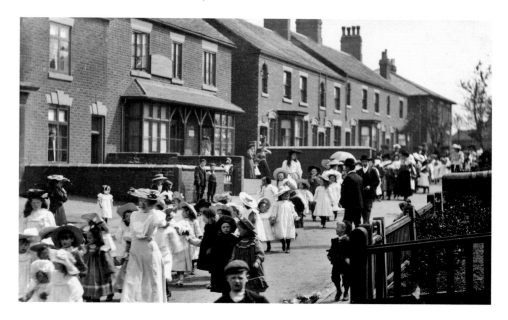

Hospital Day, 1906

Hospital Saturdays were regular events in an era when hospitals relied on voluntary contributions and local fund raising. The North Staffordshire Infirmary and Hartshill Eye Hospital were supported in this way. There were fancy-dress parades, stalls selling cakes and flowers and bands playing. In the background here are two shops: on the left, the original premises of Thomas Warham and, further up, the original Co-operative store. These were the last shops at this end of the street, which is still mainly residential. The modern shops include the fourth site of a post office on Church Street since 1900.

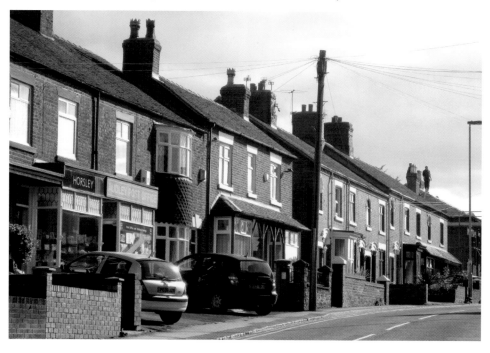

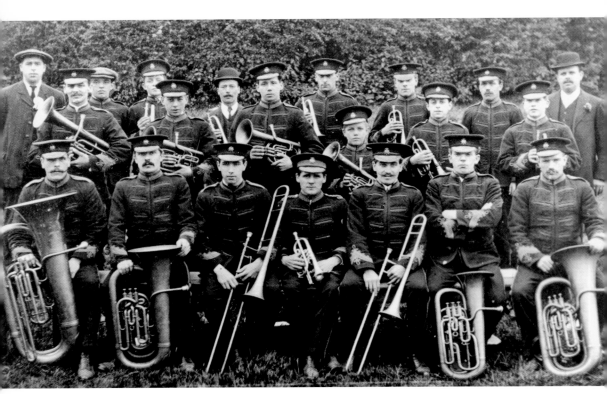

Audley Brass Band

Brass bands have often had strong links with coal mining and chapel communities. Both were present in early-twentieth-century Audley, and in 1921, the Audley Brass Band was formed. Its fifteen members 'pooled their resources and purchased a Band Room in Dean Hollow' (R. Speake, editor, *Audley Parish Millennium*). An early band, probably early 1920s, poses for the camera. The modern band marches along Dean Hollow. The band room is still in the same place, though recently entirely rebuilt, and the band continues to flourish.

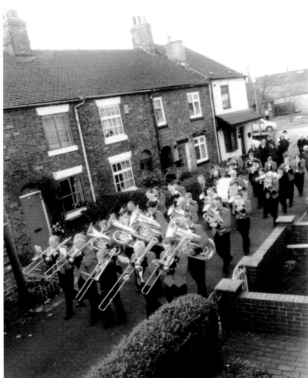

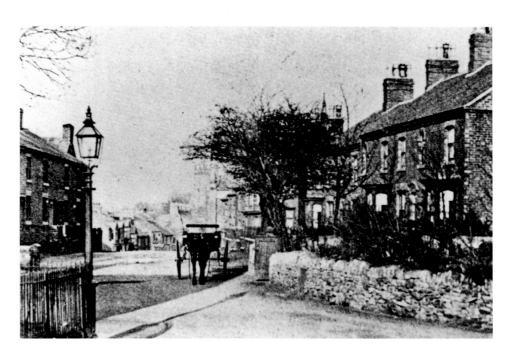

The End of Church Street

Church Street ends at the junction with Hougher Wall, Chester Road and Wereton Road. The horse and trap could well have belonged to the village doctor, Dr Vernon, who lived in a house just off camera to the right. The recent picture shows the house and the largely unchanged terrace next to it. The church is no longer visible from this point.

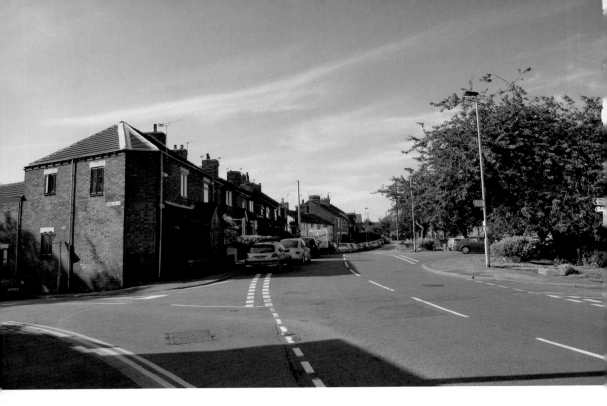

A Reverse View

This view of the end of Church Street has Dr Vernon's house to the left. Opposite was Proctor's bakery, which started business in 1882. It closed nearly a century later and, as the picture shows, was converted into private dwellings. The shop and houses on the right of the old picture have gone and the small grassy area marks the edge of the large estate of council housing developed after the Second World War.

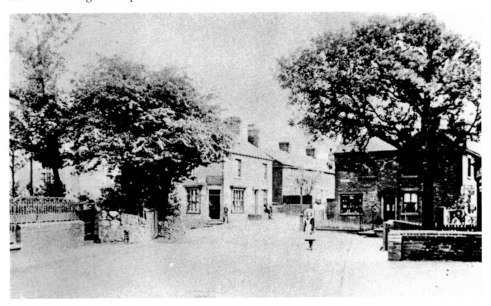

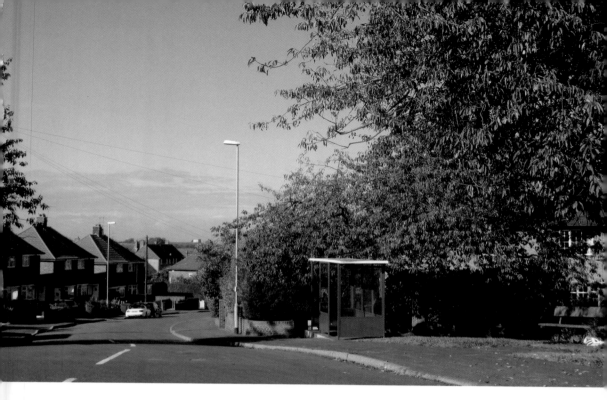

Vernon Avenue

The post-war picture shows the beginning of construction of a large estate of council houses by Newcastle Borough Council after 1945. It was part of a massive expansion of council housing in the borough and led to a large open area of the village being developed.

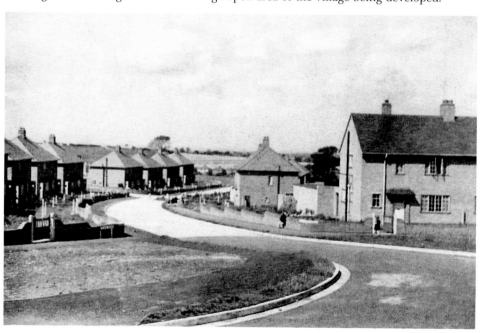

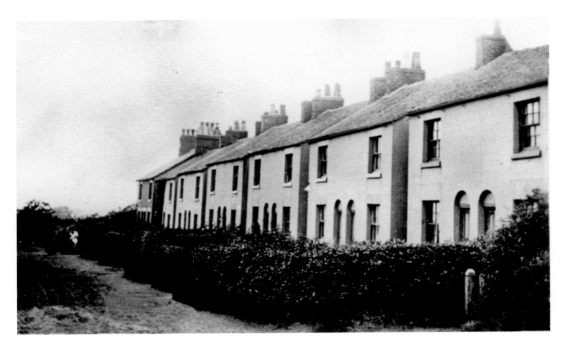

Queens Street

This terrace of houses stood at the end of earlier-twentieth-century residential development along Wereton Road. The houses looked out onto fields as the land fell away down Wynbank. Now, Queens Street marks the edge of the former council estate and is fully built up.

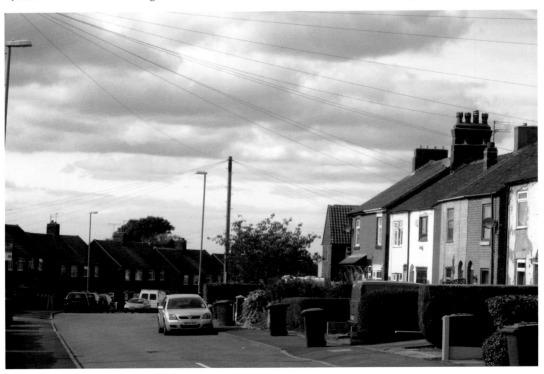

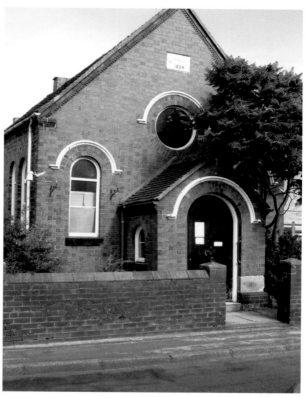

Wereton Methodist Chapel

This small Wesleyan chapel was built in 1894. A hundred and one years later, when it was no longer needed by the Methodists, it was purchased by the present occupants, the Holy Orthodox Church. In 2002, the chapel was consecrated as St Michael's. The exterior of the former chapel remains unaltered, apart from an Orthodox cross at the side. The interior, however, is very different, showing the importance of icons in the Orthodox services.

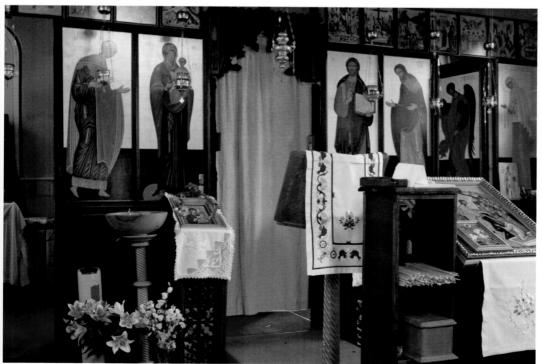

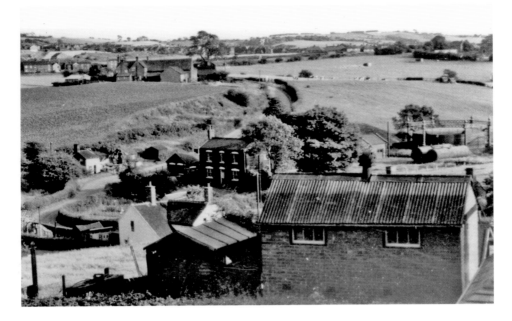

Audley Gasworks

Leaving Audley village by the Wereton Road leads down to Wynbrook and the site of the former gasworks, seen rather incongruously in a very rural setting on the right of the photograph. These works were erected in 1875 and expanded, under the Audley UDC, in 1906. The gasometer and the rest of the works and offices have gone and the area returned to rural peace. Along with the local waterworks (1891), the supply of gas was clearly of great importance in providing more modern services in the parish. In the modern photograph, the gasworks site is behind the trees to the right. The two houses (centre) remain.

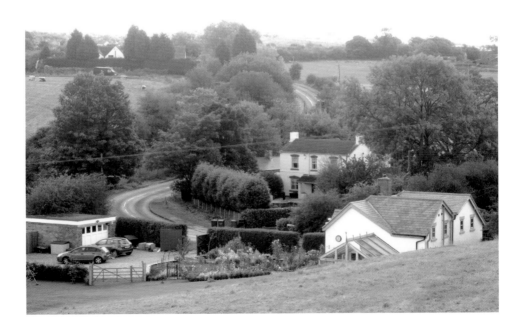

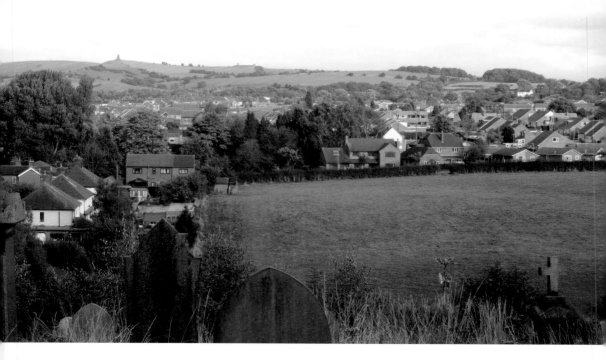

Towards Bignall End

Returning through Church Street, it is possible to stop at the churchyard for a good view of Bignall End. The older view from that point was taken in 1951. In the far distance is the Wedgwood Memorial, still visible in a truncated form. To the left are the Methodist chapel and Ravensmead Primary School, situated on what is called Old Road. In the centre is the more direct New Road. The houses stretch along this road with fields behind them. Taken from the same spot now, the view to the left has disappeared behind trees. The most noticeable change is the amount of housing on the right, Boyles Hall, once a colliery site.

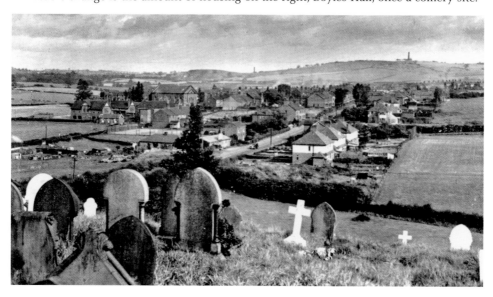

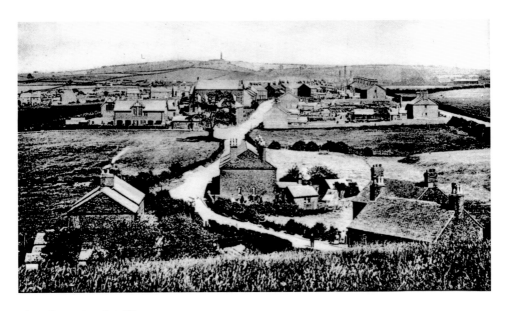

View from Castle Hill

Moving on to Castle Hill, the older picture shows the whole area left of New Road. The Wedgwood Memorial is in the distance again. On the left is Old Road, the earlier winding route to Bignall End. The whole view is no longer possible and the focus of the recent picture is on the left of centre. Here, two prominent buildings have disappeared: Audley Wesleyan Chapel and, to its left, the school, originally founded by the Wesleyans. The chapel was demolished while the old school continued use as a hall and dining room. It too has gone, and the school has had new buildings, shown here. The school is now known as Ravensmead Community School. This recent photograph shows many new buildings but emphasises the very attractive rural surroundings of the area.

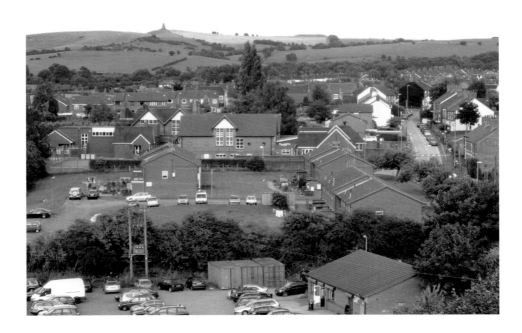

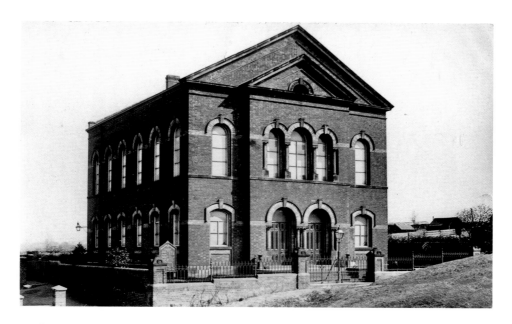

Audley Wesleyan Chapel

The chapel in Old Road was opened in 1876. It had seating for 725! There were twenty-eight chapels built in the nineteenth century in the Audley district. They are listed in the Audley Millennium book. After the chapel was demolished, a new one was built (opened 1990) on a site immediately opposite. Methodism remains strong in the area, but a study suggests that it is 'less than a quarter of that of a century ago' (D. Dyble).

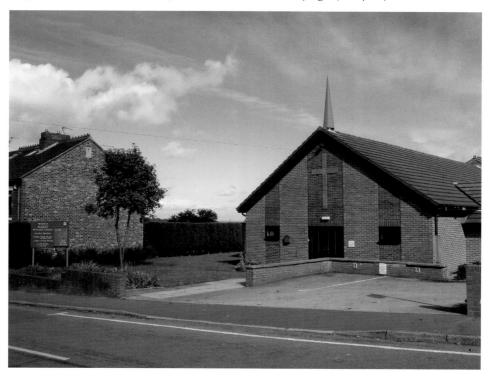

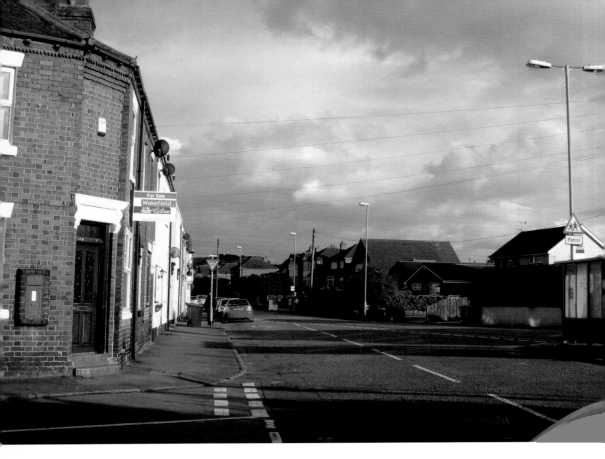

Into Bignall End

This junction leads from Chapel Street (the old road to Bignall End) and meets Ravens Lane (continuing from New Road). The event shown in the picture could be part of the celebrations for King George V's visit in 1913. The terraces to the left remain, but the right side has been redeveloped. A bus stop has replaced the seats in the centre and a modern street light contrasts with the gas light.

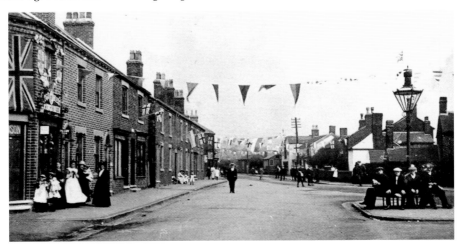

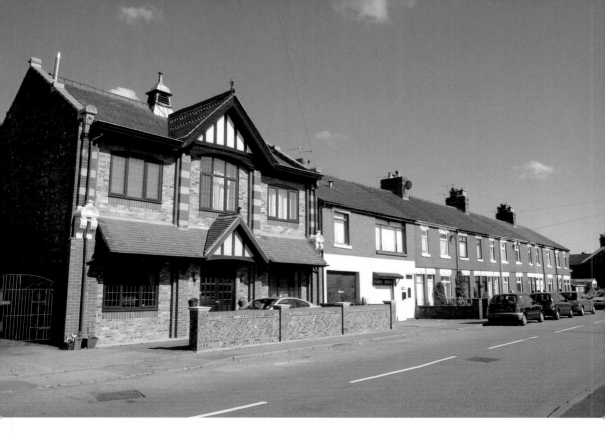

The Co-op

This was the Butt Lane Industrial Co-operative Society's shop in Bignall End, built in 1911. With the coal mining industry in full swing and employing many local men, the Co-op was an important local institution. In times of particular hardship, it has been recorded that it helped out by extending credit. Other shopkeepers succeeded the Co-op later, before the property became a private residence. The modern picture also shows some of the early terraced housing typical of the area.

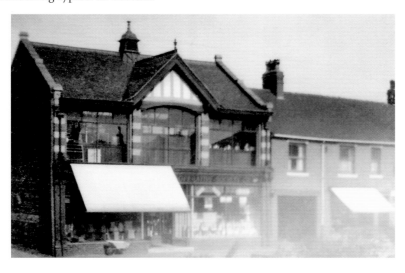

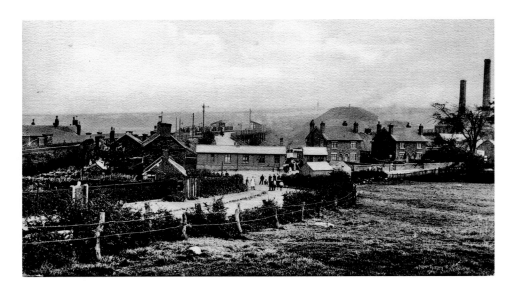

Industrial Bignall End

Thomas Warham produced this splendid view of industrial Bignall End in the early twentieth century — a view now impossible to recreate. It shows two key components of that industrial era — the railway line and Audley station buildings at the centre, and the slag heap and chimneys of Diglake Colliery to their right. Diglake was one of several collieries in Bignall End. In 1885, it suffered a major disaster through flooding, which left seventy-five men dead. The recent picture can capture nothing of the atmosphere of that time. In this much more peaceful scene, even the two houses to the right in the old picture — colliery overmen's houses — have disappeared behind the trees.

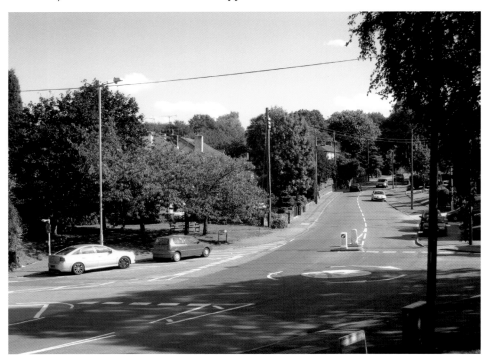

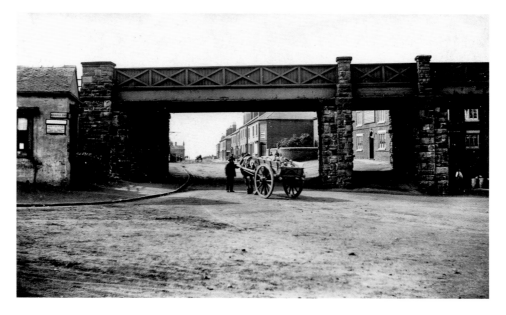

The Audley Branch Line

This bridge carried the Audley branch line of the North Staffordshire Railway Company, which ran from Keele to Alsager. Audley station is to the right of the picture. Just showing on the left is the old post office. All those features of the old photograph have gone, apart from the abutments of the bridge. However, the Plough Inn, visible through the bridge, is still in business. Beyond the inn are the terraced houses. Boon Hill is to the left.

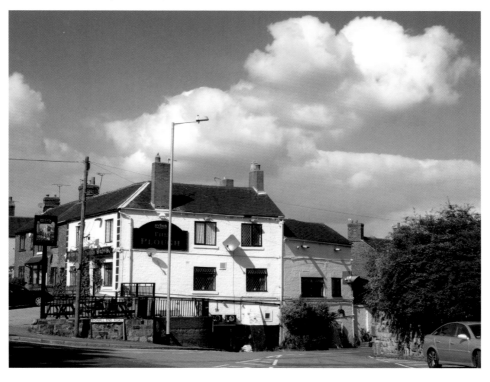

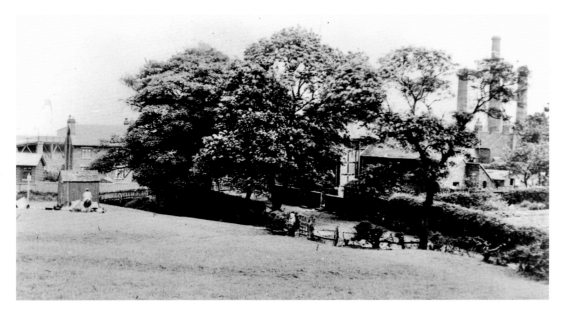

Boon Hill

In the old view, the Diglake chimneys are to the right and the station to the left. Reversing that viewpoint, it is possible to show the direction of the former railway line as it would go towards Halmer End. Again, the contrast is stark: the railway line is now a green walkway and by the embankment are modern houses.

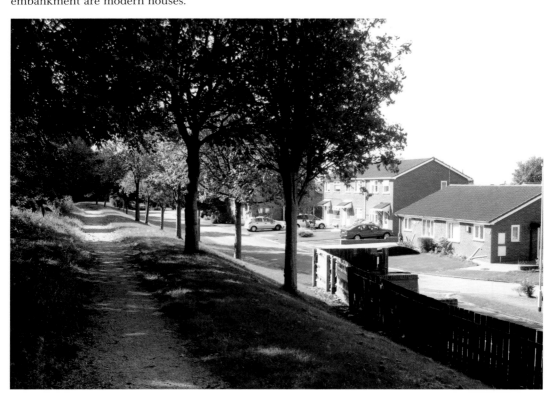

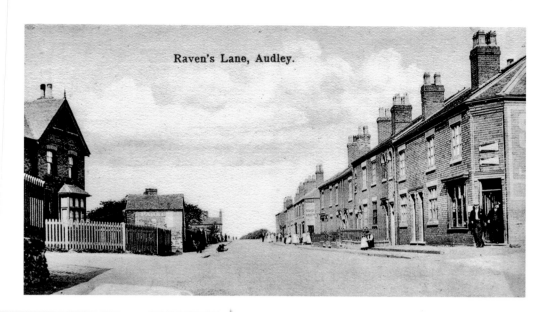

Raven's Lane, Audley.

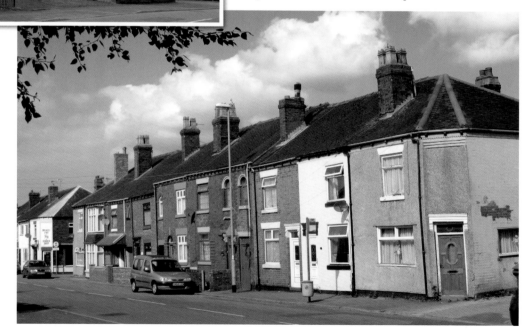

By the Station

The old picture shows the terraced housing. It is taken from near the railway bridge and on the left are the stationmaster's house and the entrance to the goods yard. The stationmaster's house remains (inset) and the terrace on the right is little changed. This part of Bignall End has a large number of these terraced houses both along the main road and in several side roads. The angled corners of these side roads have often been shops — and one modern example is shown here.

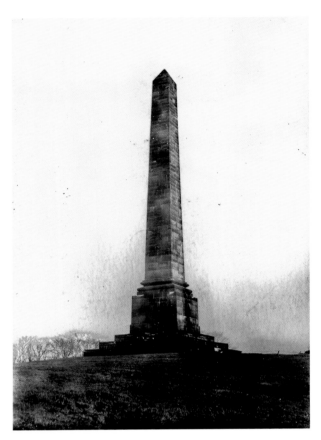

The Wedgwood Monument
The monument is a local landmark, standing on Bignall Hill. John Wedgwood, member of the famous pottery family, was a local colliery owner and MP, who died in 1839. His will instructed the building of the obelisk, under which he wished to be buried. He was in fact buried in Audley churchyard. In 1976, the monument was blown down in a storm and re-erected at about a quarter of its original height, as shown in the recent photograph. A local campaign to restore the monument has so far had no success.

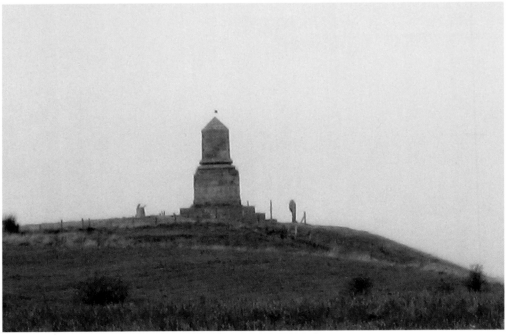

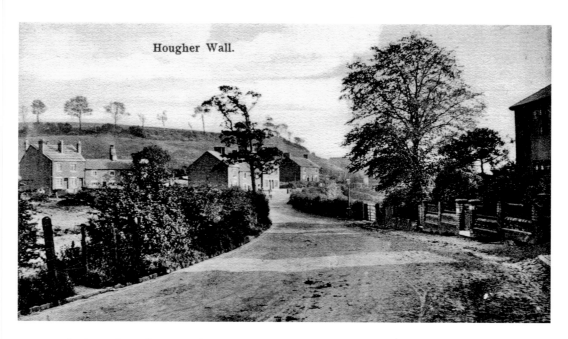

Hougher Wall.

Back Through Audley: Hougher Wall

Leaving Audley village in a different direction, the scene has not altered radically. The name, Hougher Wall, probably derives from 'hough' meaning hill, along with wall or possibly 'well'. The 'ends' and other distinctive areas of Audley parish interconnect by a series of roads and lanes. This road leads to Miles Green and then to Halmer End.

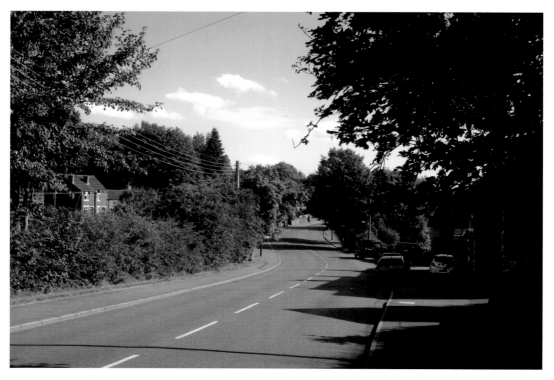

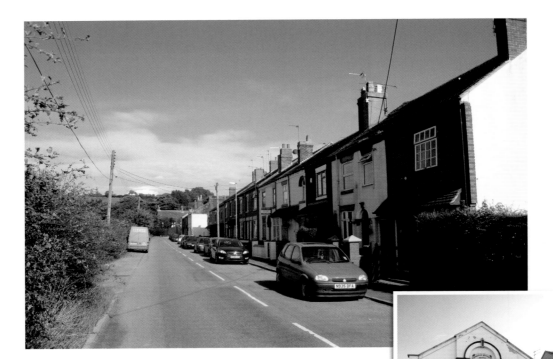

Miles Green

This road looks towards Peggy's Bank and Boon Hill. Again, there
is not a great deal of change in the modern view, with one obvious
exception — the number of vehicles! The houses to the right date
from the early twentieth century. Where the solitary cart has been
left was the Primitive Methodist chapel (1880). The building remains,
now part of a private property, and is shown in the inset. It is
another example of the widespread locations of chapels in the area.

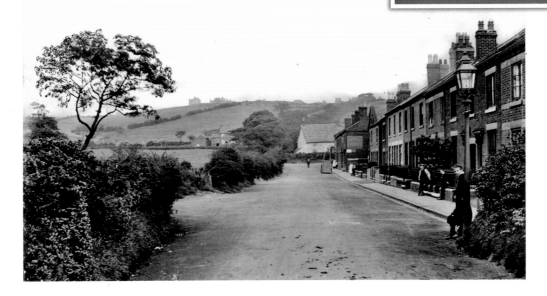

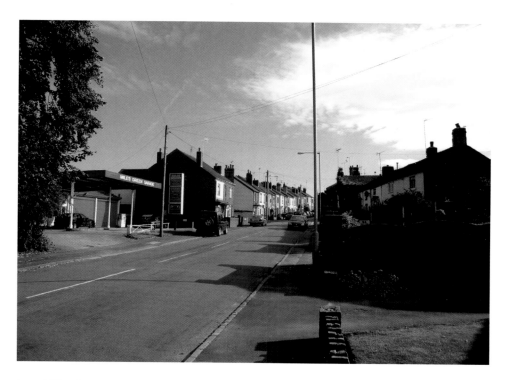

Into Miles Green

The old photograph shows bridge parapets over the Dean Brook, old cottages on the right and terraced housing on the left. This area was once called Jumblers Brook. The modern photograph shows considerable change. The old cottages immediately on the right, probably dating from the 1830s, have gone. The garage has been in business since 1928. It ran bus services to Newcastle under Lyme and Stoke until the 1950s. A right-hand road — Station Road — leads to Halmer End.

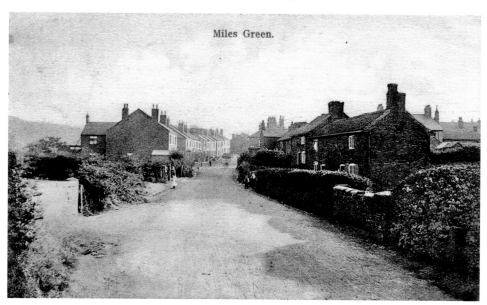

Miles Green.

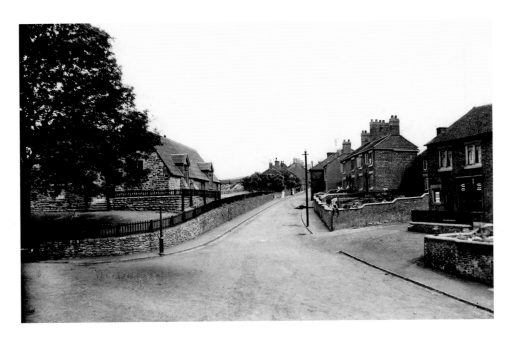

Halmer End School

At the junction of Station Road and Halmer End High Street, to the left, is the school, originally a national school (1849), later a council school and now the Sir Thomas Boughey High School. The old school, shown in the picture of *c.* 1916, was finally demolished in the 1980s, and the school has been enlarged and modernised. To the right, the shop has gone, absorbed into the Station Inn public house. This dates from the opening of the Audley branch line in 1870.

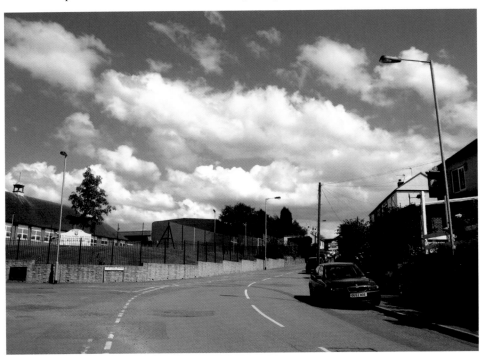

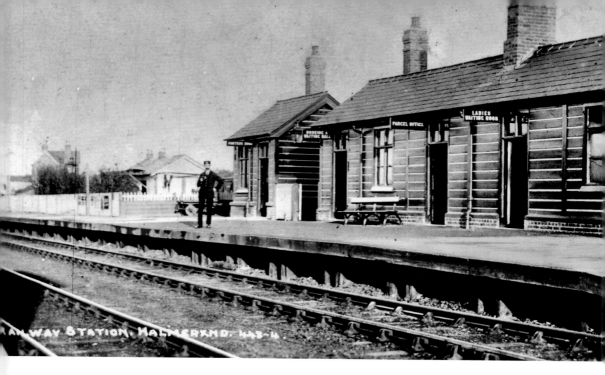

RAILWAY STATION, HALMEREND. 443-4.

Halmer End Railway Station

The Audley branch line started at Keele and ended at Alsager. It served the coal mines in the area from 1870, with stations at Leycett, Halmer End and Audley. The line also carried passengers from 1880 until 1931. Like Audley station, the buildings were functional. In the picture, the stationmaster surveys his domain. The line was closed in 1962. All trace of the station has disappeared to be replaced by the housing shown in the modern picture. The line ran through the wooded area at the end of this view, now a walkway.

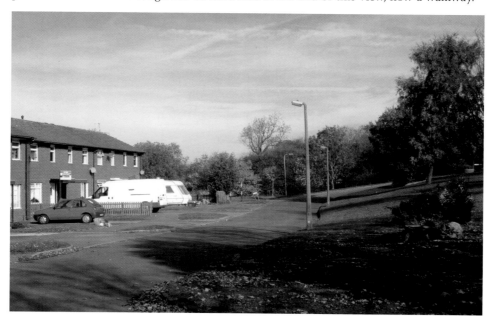

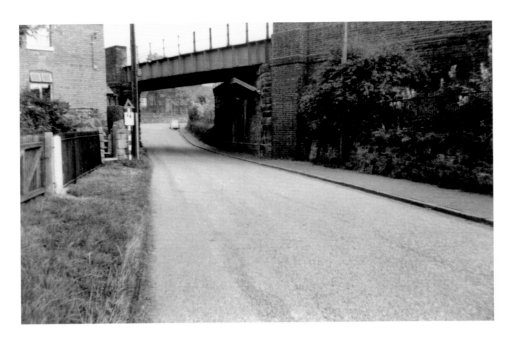

The Railway Bridge at Halmer End

This was the bridge that took the line over the road, just before it entered the station. On the left are Railway Cottages. The junction with Station Road, from Miles Green, can be seen after the bridge. Only the abutments of the bridge remain, but the cottages still stand. The site of the Minnie Pit, which the railway served, is just down the road from here.

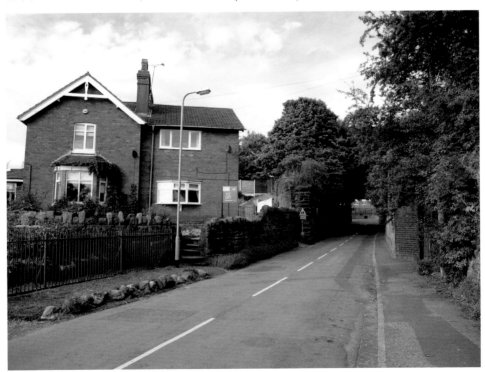

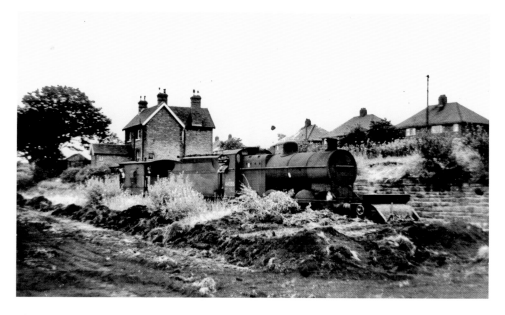

The End of the Line

This picture shows the track-lifting train that brought the railway era to an end in the area. The line of the track can still be traced along the public walkway from Halmer End to Bignall End. The house in the background is the former stationmaster's house. It is now a private residence, shown in the modern picture.

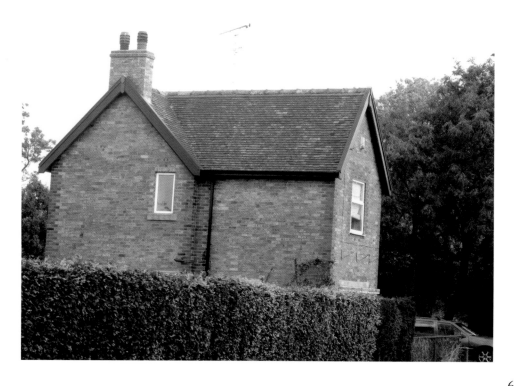

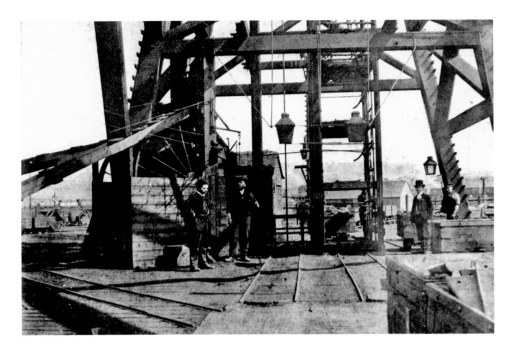

The Minnie Pit Opens

The Minnie Pit, belonging to the Cooper and Craig company, was sunk in 1883. It was long thought to be named after Craig's daughter, but it was in fact named after another relation. Craig is possibly the figure (with a hat) on the right. Later on, the Minnie, with its two sister pits, Burley and Podmore, were run by a larger concern, the Midland Coal, Coke and Iron Company. When the industry became depressed in the '20s and '30s, the pits were closed. The site has now been imaginatively landscaped and become Bateswood Wildlife area.

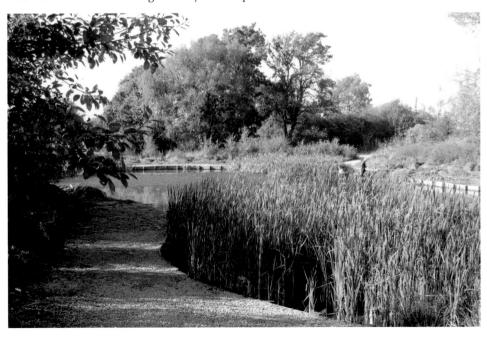

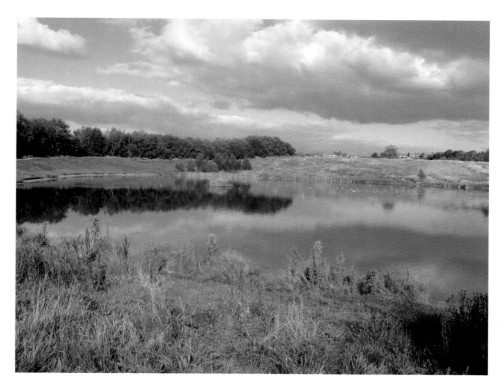

A Familiar Scene

In the early twentieth century, the pithead winding gear, the yardsticks, or 'yerdsticks' locally, were familiar symbols of the extensive coal mining industry of the parish. Some of the employees have here gathered to have their photograph taken by Thomas Warham. Another view of a very different kind illustrates the transformation of the old industrial area.

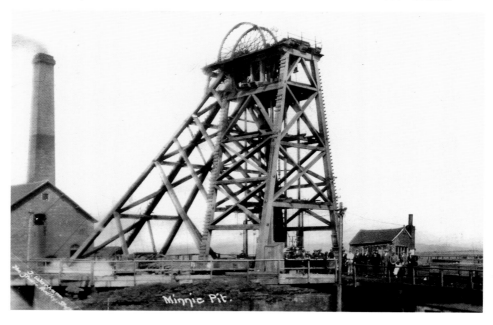

Minnie Pit.

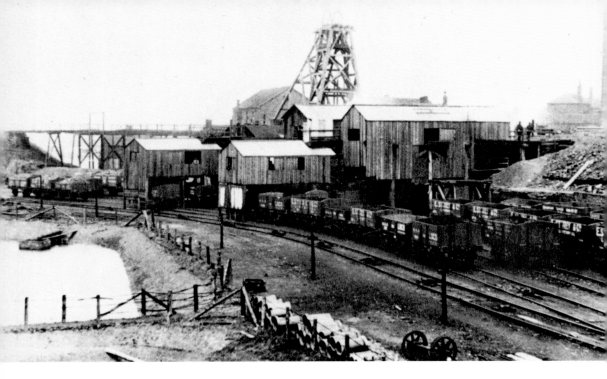

The Railways and the Pits

The railways were essential in moving the coal from the pits. A network of rails is shown in this picture of the Podmore Hall colliery at Halmer End. The pit became the property of the Midland Coal, Coke and Iron Company, some of whose wagons are depicted here. The pit head rails linked with the Audley Branch line of the North Staffordshire Railway. Only a faint trace of these railway networks survives, a bridge in the Bateswood Wildlife area that was once the site of the Minnie pit.

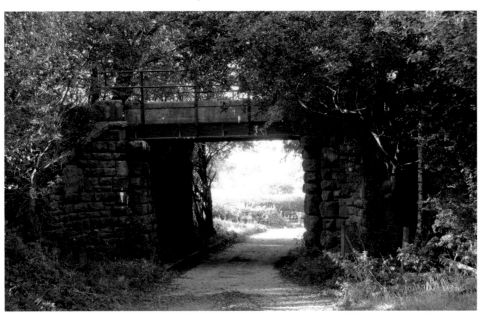

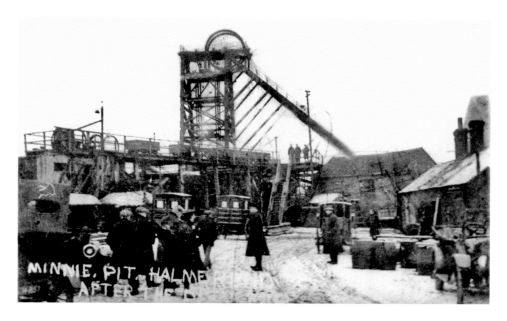

The Minnie Pit Disaster, 12 January 1918

An explosion occurred in a part of the pit that resulted in the deaths of 155 men and boys out of the total of 248 who were at work underground at the time. The vast majority died through gassing by carbon monoxide: 'this disaster, coming as it did towards the end of the 1914-1918 war, stunned the village. All the victims were local men.' (R. Speake). The photograph of January 1918 shows ambulances and cars at the site after the explosion and huddles of men being addressed by a figure in uniform. It is very evocative of the misery of the events. At the edge of the wildlife area is a memorial: 'To all who lost their lives in the fight to extract coal from the mine, 1890-1931'.

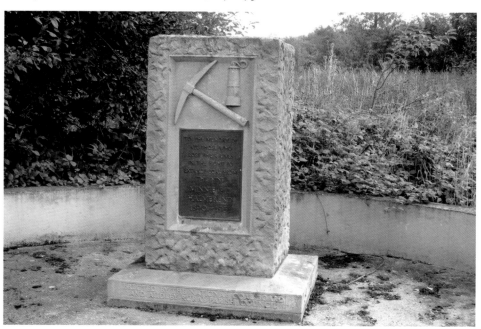

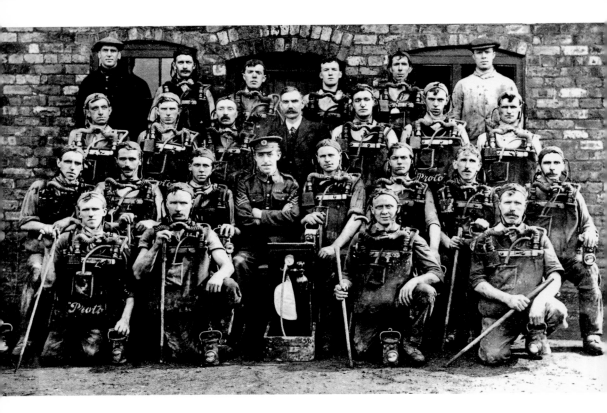

The Rescue Team

One member of a rescue team died and the bravery of the teams was highly commended at the official inquiry, held after the disaster. Here they are shown wearing their breathing apparatus. The inquiry found that the explosion was caused by the igniting of methane (fire damp) but was unable to explain why it had ignited. A second memorial is shown here: 'In memory of the 155 men and 1 rescuer who lost their lives in the Minnie Pit disaster, June 12, 1918'.

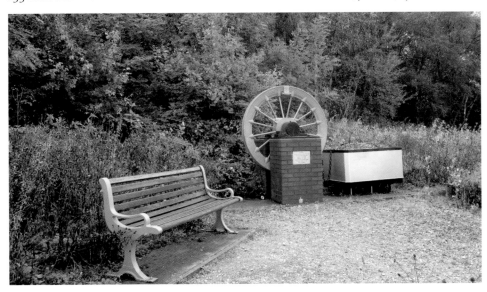

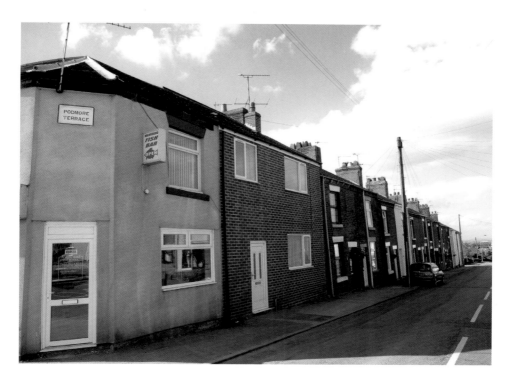

Podmore Terrace

On Halmer End High Street is Podmore Terrace. All but two of the houses depicted were built by the Midland Company. Podmore pit was along the lane that starts by the fish and chip shop on the corner of the terrace. These terraces, though often modernised, remain as a clear reminder of the way the coal industry affected the appearance of parts of the parish.

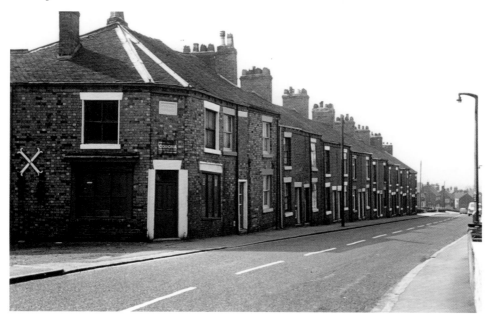

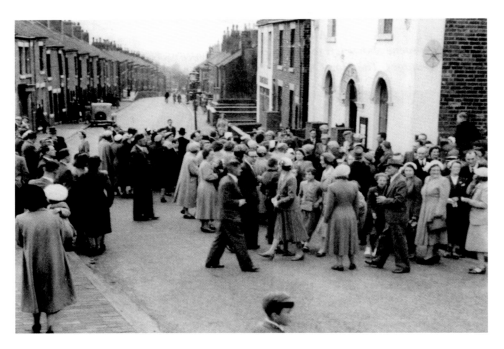

The Primitive Methodist Chapel

One of the survivors, this chapel was built in 1867. The picture, taken in 1953, shows the large congregation able to linger in an almost traffic-free High Street. It also shows very well the fashions of the '50s. On the left are the Podmore and Railing Row terraces. In the modern picture, Railing Row has gone. Otherwise there is little change, apart from the traffic.

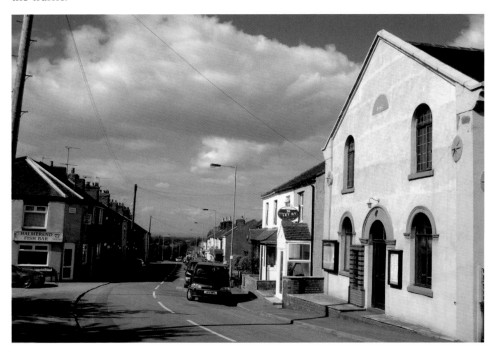

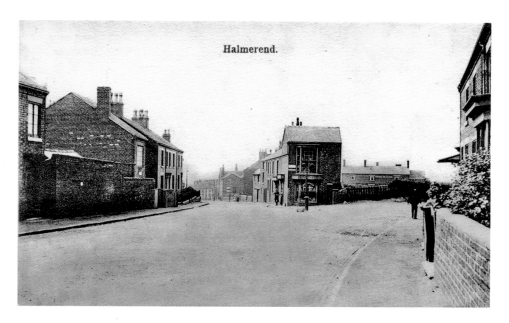

Halmerend.

The Top of Halmer End High Street

At this junction, the High Street meets the road from Miles Green and then changes climbs up to Alsagers Bank. The premises at the centre of the junction belonged to W. Riley & Sons, seedsmen and general merchants. It was also the post office. This long-standing family business has moved to new premises on the left. After a spell as a restaurant, the former Riley premises are now a private residence.

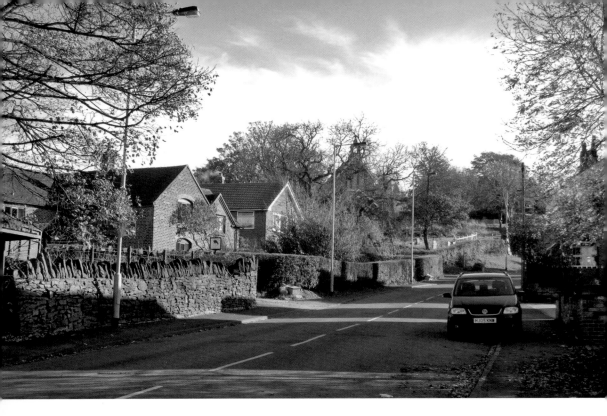

Towards Alsagers Bank

Here, the road leads up to the heart of Alsagers Bank. To the left is Church Farm, which in fact is at least 100 years older than the church, which here comes into view. This picture was taken at the beginning of the twentieth century. There is a new building but otherwise little has changed.

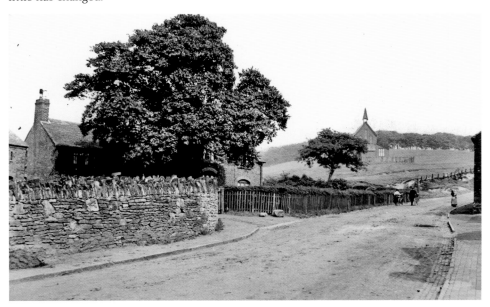

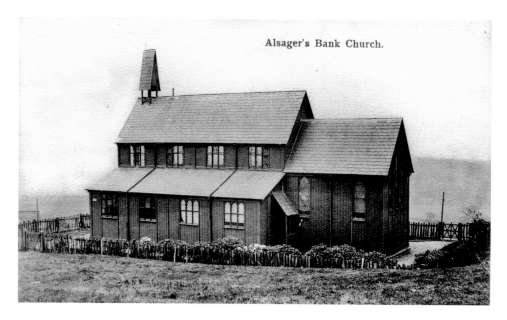

Alsager's Bank Church.

Alsagers Bank Church

The church in the old photograph was built in 1875, a rather temporary looking structure of wood and corrugated iron. The funds for its building were provided by Captain J. H. E. Heathcote, a local industrialist who lived at nearby Apedale Hall (now demolished). In 1911, it was replaced by the brick building, which still stands. Originally in a neighbouring parish, the church is now administered by the vicar of Audley. In 1839, the Heathcote family also founded the school in Alsagers Bank.

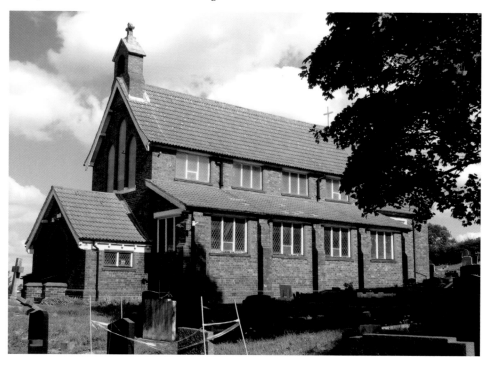

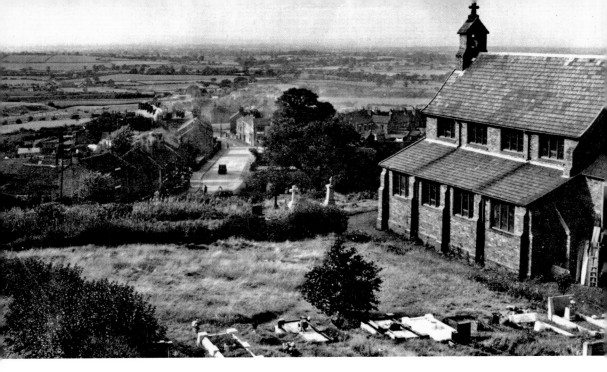

The View from the Churchyard

The exact viewpoint of the 1951 photograph is now hidden by trees. However, both pictures show the magnificent view over Halmer End to the Cheshire Plain, the Peckforton Hills and the Welsh mountains beyond.

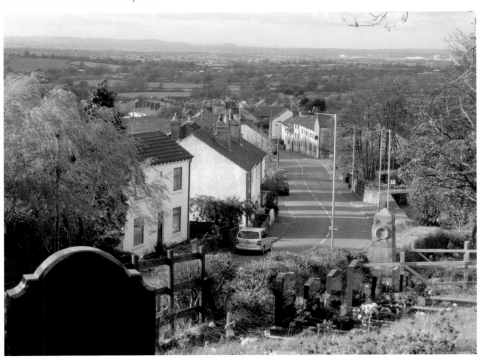

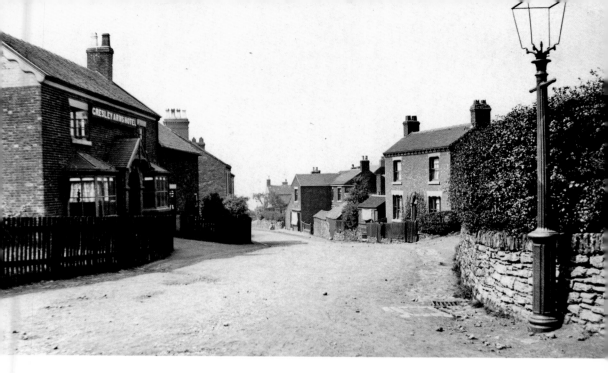

The Gresley Arms

The Gresley Arms is situated at the top of Alsagers Bank. It is listed as a public house in 1834 and is named after Sir Nigel Gresley, an early-nineteenth-century industrialist in nearby Apedale and the builder of a canal in Newcastle under Lyme.

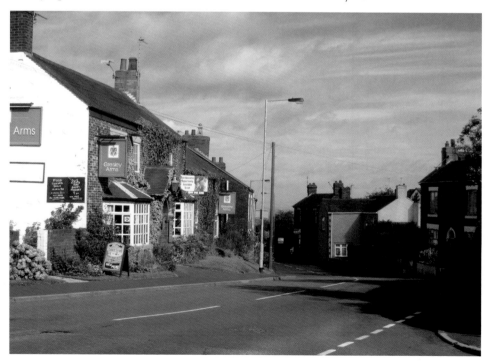

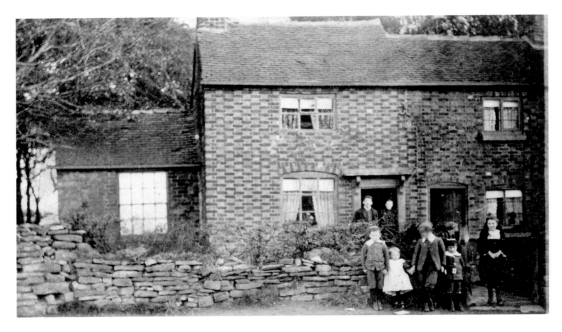

A Changing Scene

The old picture shows the end houses of a terrace that is the predominant style of housing in Alsagers Bank. In more recent times, demolitions have broken up this pattern. In this example, the old houses were demolished and replaced by the modern bungalow illustrated here.

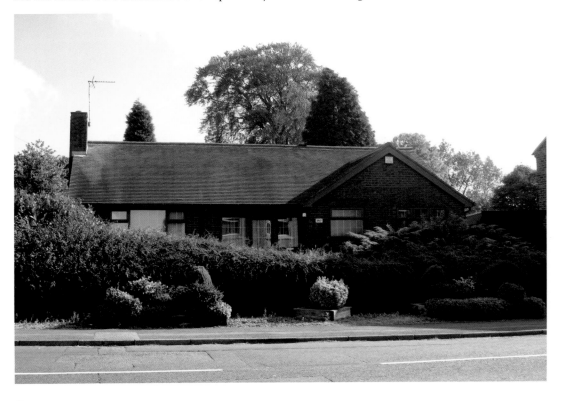

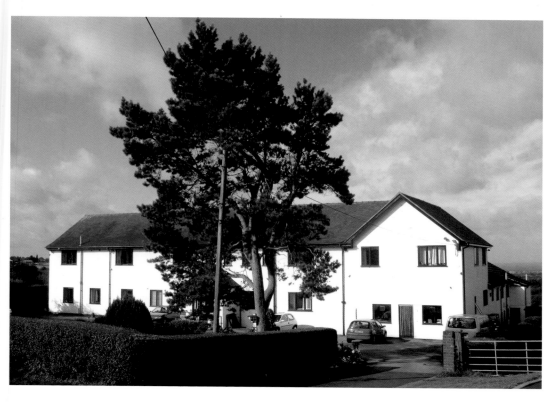

The Old Parsonage

The older picture shows the original parsonage at Alsagers Bank. It is now, in much extended form, the Poplars Residential Home. It overlooks more magnificent views across the Cheshire Plain.

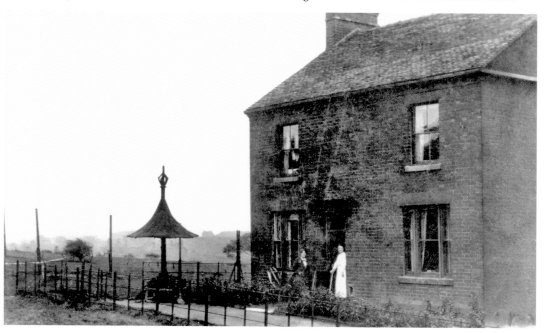

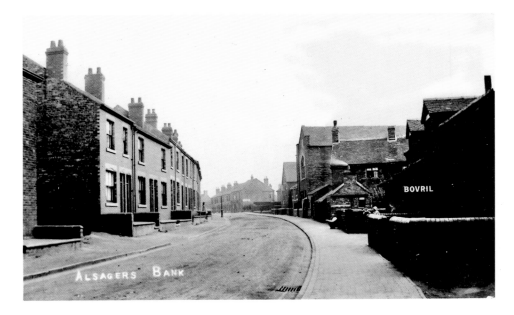

Alsagers Bank, High Street

Probably the oldest house still standing in Alsagers Bank is indicated by the old Bovril sign from its days as a shop. It may date from 1763. Looming up beyond this house are two chapels, only a short distance from each other. They were called Zion and Epworth. Epworth (1855), in the distance, was Wesleyan. Zion (1870) was a United Methodist Free Church. There was great rivalry between these two strands of Methodism, not entirely cured by their unification in 1932. On the left is early-twentieth-century terraced housing. The chapels have both been demolished and bungalows built in their place.

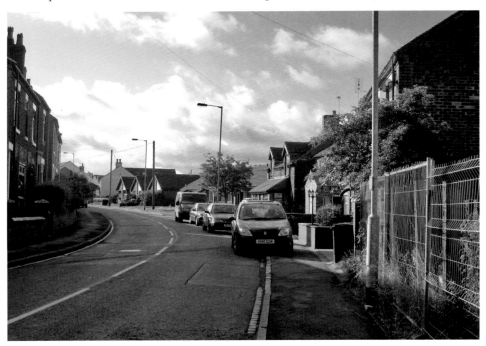

Looking Back to the Chapels

The closeness of these rival chapels is illustrated in this view. The modern picture shows very clearly how their demolition has changed this section of the High Street. The house on the right in the old picture is discussed in the next pictures.

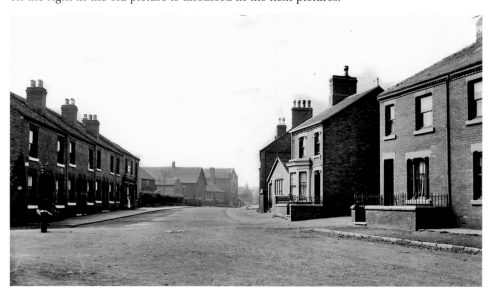

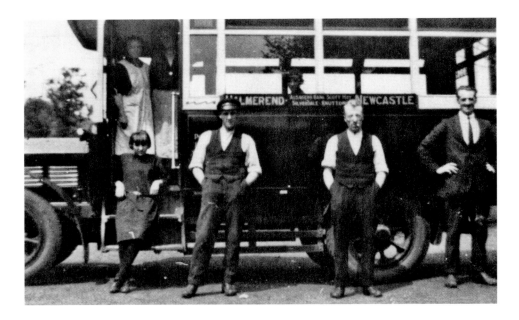

Poole's Buses

One of a number of local bus companies, Poole's operated a variety of local services. The family are photographed in front of one of their buses. The family business was founded in the 1920s by Mrs Alice Elizabeth Poole. Her husband and eldest son had died in the Minnie Pit disaster, and Mrs Poole used her compensation from that event to found the bus company. The old picture shows members of the family in front of one of their buses. The business closed in 1987. The bus depot beside the much-altered house is now a kitchen and bedroom firm.

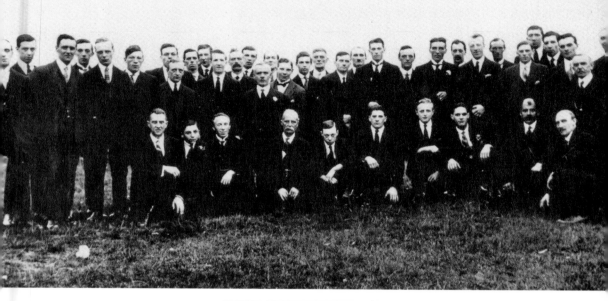

Male Voice Choirs

Choirs, like brass bands, were often a feature of areas where mining and chapel-going featured. The Alsagers Bank Male Voice Choir is featured in the 1924 photograph. Many of its members came from Methodist choirs, and it sometimes gave evening concerts on Alsagers Bank cricket ground. More recently, Audley Male Voice Choir has had great success locally. The picture shows the choir in the Victoria Hall in Stoke on Trent.

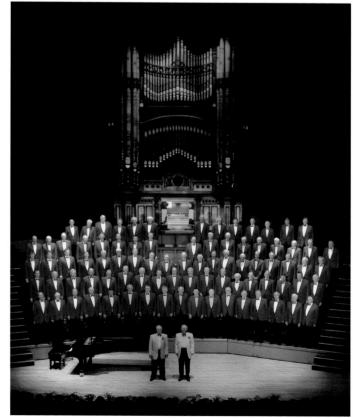

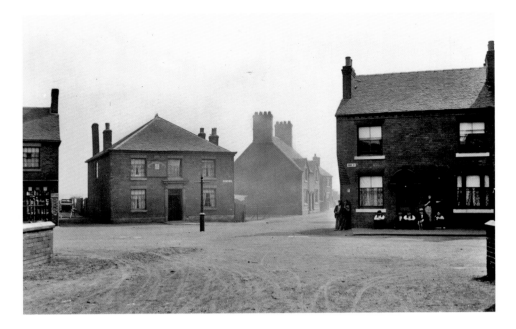

The Farmer's Boy

This former public house is now a private residence. It is recorded as a public house in 1861 and finally closed in 1983. The records of buildings in Audley are littered with references to former public houses. Their closure is not simply a modern phenomenon. As well as public houses, shops too have disappeared widely and, with the closure of its post office last year, Alsagers Bank has no shops left. At this junction, the road to the right leads to Scot Hay. Straight on leads to Knutton and Newcastle under Lyme.

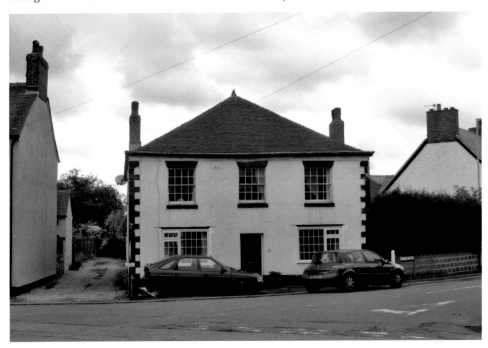

Wood Lane

From Miles Green a steep lane known as Peggy's Bank leads to Wood Lane and the view here. On the left, out of view in the early picture, stood one of three chapels in this small community. The view shows a narrow street with the school just appearing to the left. New houses have appeared in the recent view.

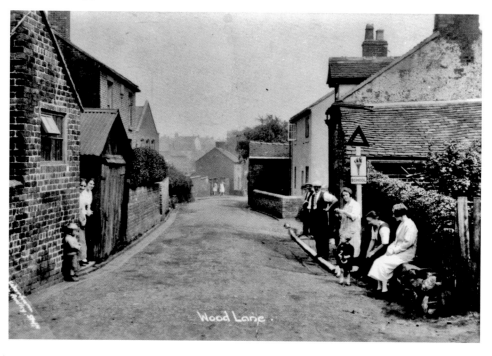

Wood Lane.

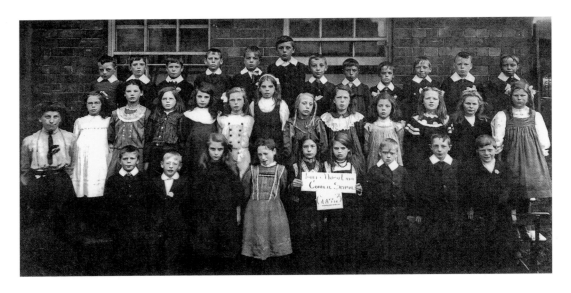

Wood Lane School

The very early photograph is of Class 3 at Wood Lane Council School. The school, considerably modernised, has just celebrated its centenary. The early photograph is a fascinating portrait of the childrens' costume of the day. It seems a very well turned out class!

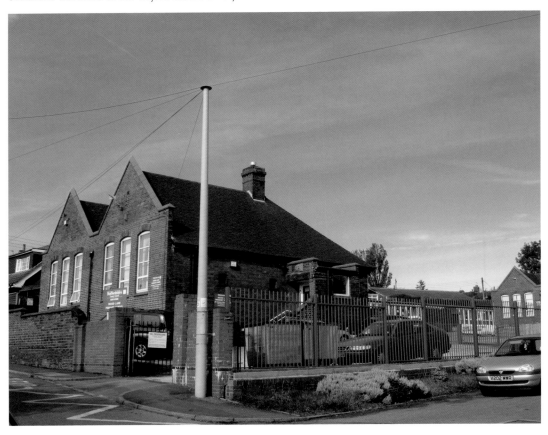

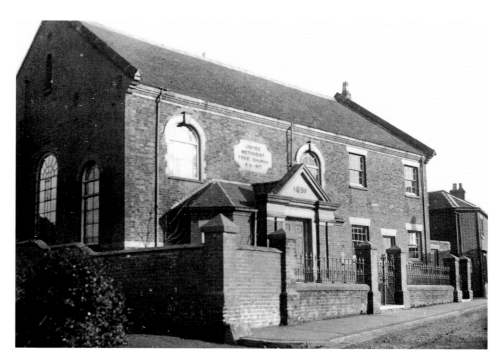

Wood Lane Chapels

The number of Methodist chapels in the small community of Wood Lane well illustrates the enthusiastic support given to the movement in the 1860s to 1880s. The United Free Methodist chapel (1875), which is illustrated, thrived alongside the Wesleyan Chapel, shown below, and a Primitive Methodist chapel. Only the Wesleyan chapel survives.

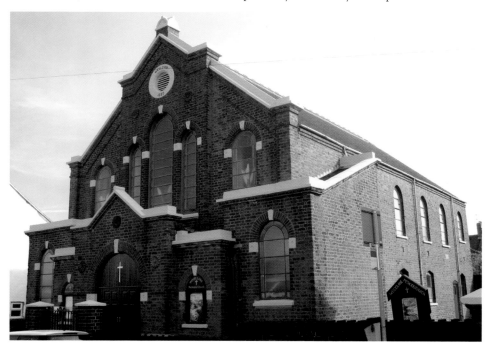

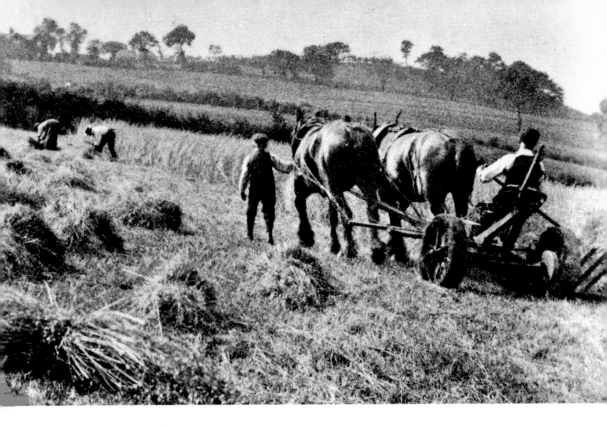

Farming in Wood Lane

There are very few photographs that reflect the agricultural life of the village before mechanisation. This nostalgic scene shows a horse-drawn reaper, with the binding of sheaves of corn in the background. The modern picture tries to capture the continuing peace of this rural scene.

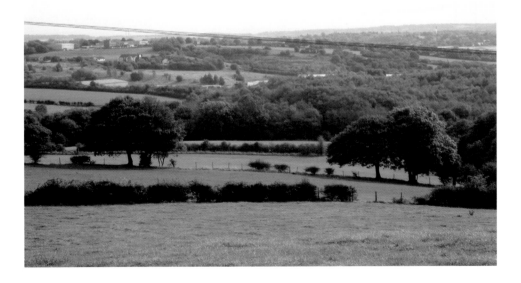

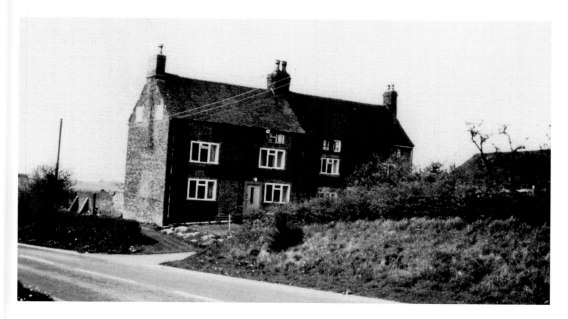

The Workhouse

This building can be seen on the last part of the journey around the parish. It is the surviving part of the village workhouse of 1734, which functioned until the new Poor Law of 1834. The poor of Audley were then sent to Newcastle. The poor of those days would not recognise the present building. It stands on Alsager Road, now the route of commuters as they speed towards the A500, the link to the M6, some two miles distant.

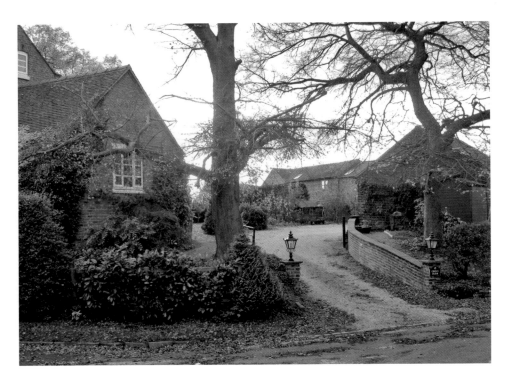

Cross Farm

Just before the A500 is the narrow lane to another of the 'ends' of the parish, Mill End. At the start of the lane is Cross Farm. Now a private dwelling, it has been a farm for most of its existence. It belonged to a maltster in the mid-nineteenth century, with the malthouse at the rear. The figure in the drive is Henry Fynney, the miller, whose family farmed here until 1965.

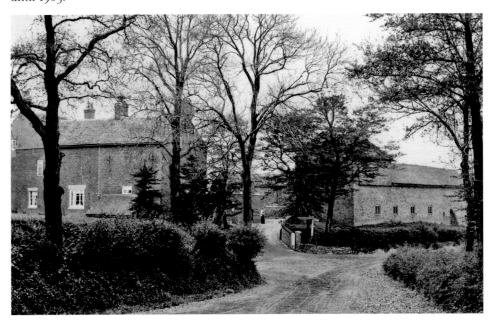

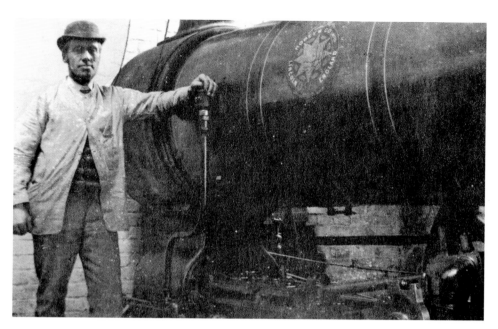

Mill End

Here is Mr Fynney in 1910 with the Robey boiler and engine, which then drove the mill. His family operated the mill from 1896 to 1966. As the recent picture shows, the mill buildings still stand in their attractive location. The wheel house shown here has a large, overshot wheel, 13 feet 9 inches by 3 feet 6 inches. It is now a private property. With the mill pond next to it, the scene makes an attractive end to the journey through Audley parish.

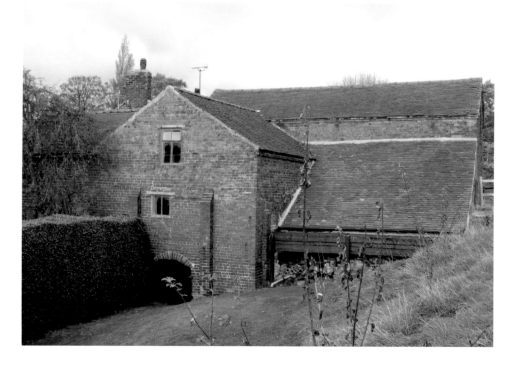

Acknowledgements

First I must thank Robert Speake. He pioneered the serious study of Audley's history with his classes in the early 1970s and the resulting book, Audley (1982).He has encouraged me and helped me with his wide knowledge of the area.

My second port of call was the Audley and District Family History Society their excellent website has been invaluable: www.acumenbooks.co.uk/audleynet/famhist

Much of their material has been has been meticulously researched by Clive Millington. I am especially indebted to Clive who was generous with his time and his help in gathering photographs

Perhaps most important of all to a book of illustrations was the generous help of Miss Louisa M. Warham: she most generously gave me access to all her father's photographs that make up the basis of the historical pictures in this book.

I would like to say a special word of thanks to Christine Warrillow who so readily allowed me the use of two of her father's photographs :the views of Audley from Audley churchyard and that from Alsagers Bank churchyard.

Many others have helped with old photographs and their knowledge of the villages: Philip Broadhurst, Christopher Cooper, Joan Downing, Wendy Jessop, Reg and Pauline Johnson, Ted and Phillippa Llewellyn, Margaret Lomas, Eileen and Barry McGuire, Ernie Moulton, Ruth Nix, James Pointon, Pam Spence, Joan Tomkinson, John Whitehead. Then there all the people I met in my travels round the parish, many complete strangers, who had useful information and encouraging comments about this project.

The results of my efforts might have gone for nought without the technical help with the computer and the infinite patience of Linda Forrester

Finally, Sarah and Ruth helped in various ways and Jane dropped everything when I needed help, took some wonderful photographs and put up with the traumas of book writing.

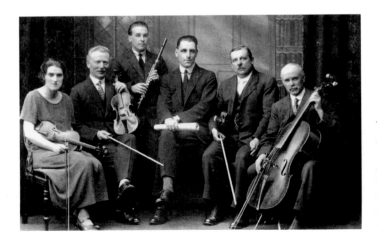

Thomas Warham and the Audley Sextet — Warham, on the right, a photographer, is responsible for many old photos in this book.